On Campaign

The Civil War Art of Keith Rocco

On Campaign features dozens of previously unpublished works by Keith Rocco, to include drawings from his sketchbooks and paintings commissioned for private and corporate collections.

On Campaign

The Civil War Art of Keith Rocco

Text Written by:

Peter Cozzens • D. Scott Hartwig

Book Designed & Edited by:

Dana F. Lombardy

Cover Designed & Layout by:

Ronald A. Ellis
Studio 500
Charlottesville, Virginia

The Emperor's Press
Chicago, Illinois

1994

I.S.B.N. 1-883476-01-1

Historical Art In Perspective

Text by Peter Cozzens

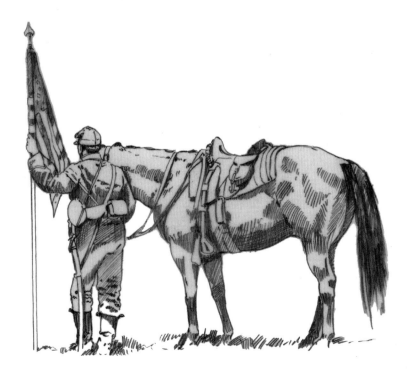

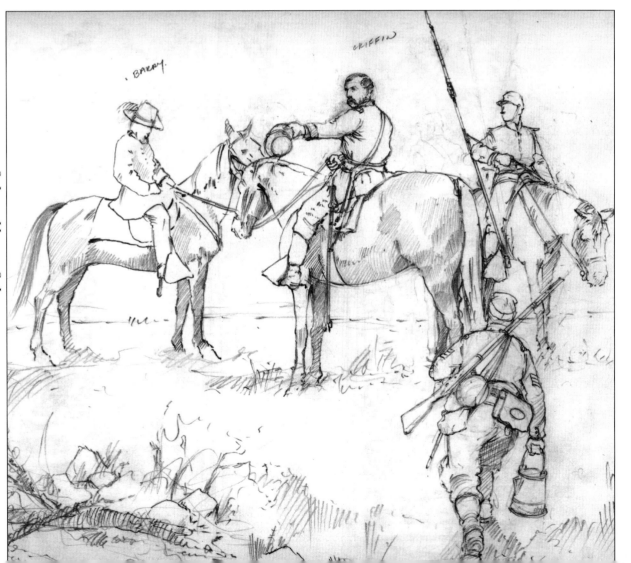

Capturing the essence of combat poses perhaps the greatest challenge to an artist. To evoke the true horror and pathos of battle would seem to directly contradict the conception of art as the human effort to imitate or interpret the work of nature. Art is the conscious production of forms and colors in a way that touches the sense of beauty; war is the antithesis of beauty, a gross violation of nature that presumably should repel the person of feeling. Yet there arose in Nineteenth Century Europe a group of artists who by their very sensitivity and skill were able to bring war realistically to canvas — often with a haunting beauty that disarmed the viewer. Adherents of the

"French Realist School," their work satisfied both the cultivated tastes of the continent and exacting European standards of historical realism.

Among the first during this era to regard war as a legitimate subject of artistic expression was the renowned French painter Jean Louis Ernest Meissonier (1815-1891). Schooled in the tradition of Seventeenth Century Dutch realists, Meissonier brought to his work a near obsessive concern for historical accuracy. Married to a genuine talent, Meissonier's passion for precision produced works of rare sensitivity and life, free of the anachronisms that had long plagued military art.

Moved by an urge to celebrate the lost glory of Napoleon's empire or by a patriotic duty to restore national pride after France's humiliating defeat in the Franco-Prussian War, other French artists gave their talent to war art. Outstanding among them were Alphonse de Neuville (1835-1885), Henri Felix Philippoteaux (1815-1884), and Edouard Detaille (1848-1914).

Philippoteaux and Detaille dedicated themselves largely to French themes; de Neuville was more eclectic, and his most famous work was a scene of British glory, *The Defense of Rorke's Drift*. He was also the least subject to occasional flights of romantic fancy; for all their strict adherence to realistic detail, the French artists sometimes reworked the broader outlines of history on their canvases to meet the public demand for works that glorified the nation's military past. Unlike the others, however, de Neuville had tasted the most potent tonic to romanticism — battle. He fought in the Franco-Prussian War, and he gave expression to the horrors he had witnessed in a black, macabre style very

"Cleburne at Ringgold Gap"
1994

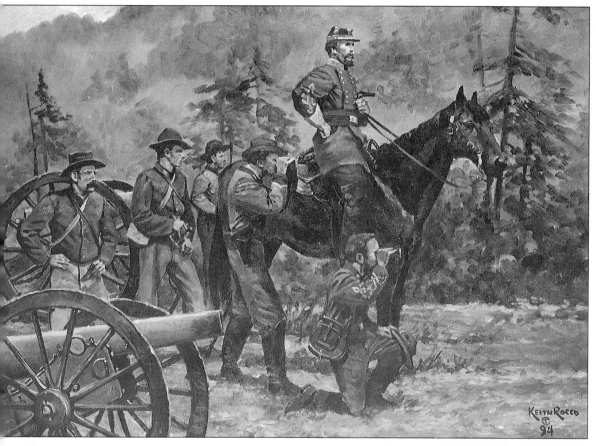

different from the parlor artists of the day.

The efforts of the French realists were rewarded, both critically and financially. War paintings sold. Huge cycloramic views of heroic French stands against the Prussians were immensely popular, and de Neuville and Detaille collaborated to produce two of the best. Depicting the Battles of Champaigny and Rezonville, they were magnificent in scope yet correct to the smallest detail.

English artists were quick to capitalize on the success of their French colleagues. The first and perhaps most popular of the British military artists was a woman, Lady Elizabeth Southerden Thompson Butler (1846-1933). Admired both in England and on the continent, she is best remembered for her dramatic depiction of the charge of the Royal Scots Greys at Waterloo, *Scotland Forever.* A wonderful bit of romantic painting, it fails badly by any standard of realism: the horses are too close together, their gallop too fast and frenzied. Despite her liberties with historical veracity, Lady Butler was regarded by Meissonier as the finest military artist in Great Britain.

Lady Butler had adopted Meissonier's realistic style, if not his fidelity to history. Richard Caton Woodville's (1856-1927) popularity in England rivaled that of Lady Butler during the latter half of the Nineteenth Century. Like her embellished and occasionally romanticized works, his art suited the demands of a British Empire anxious to trumpet its colonial triumphs to the world. Among Woodville's most popular paintings were those of battle in exotic places, such as *The Relief of Lucknow, The Guards at Tel-el-Kabir*, and *The Charge of the Twenty-first Lancers at Omdurman*.

The techniques and high standards of historical detail of the French realists made

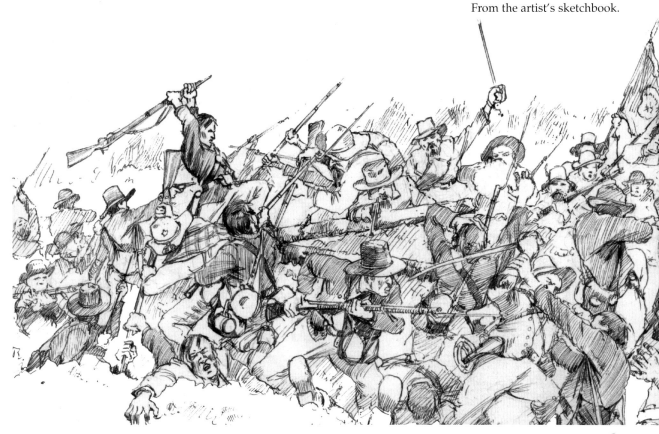

From the artist's sketchbook.

"Berdan's Sharpshooters at Gettysburg"
1991

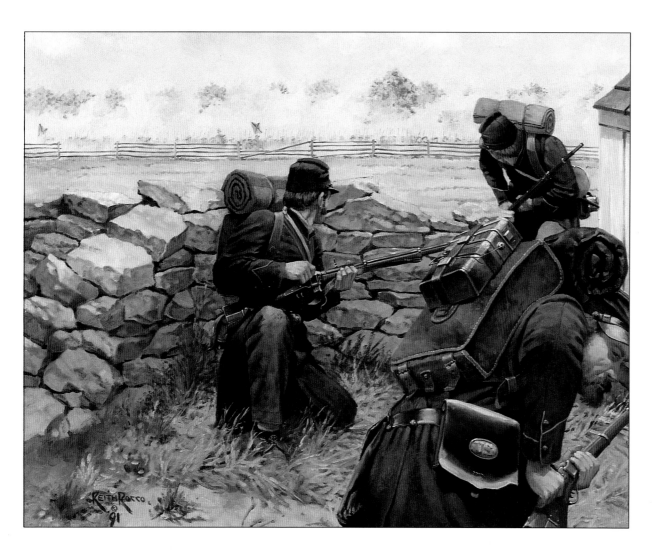

their way to America coincidentally with the outbreak of the Civil War. The war itself provided fertile ground to American artists eager to try these techniques on military themes. Illustrated newspapers of the day offered a ready market for their earliest works, which most often were "on-the-spot" drawings depicting battles or everyday camp and field life. The best of the combat artists, like Winslow Homer, graduated to greatness. Homer recognized both the contribution of his wartime work to his success and the intrinsic worth of military art. Long after he had established himself as one of America's preeminent artists, Homer continued to

paint scenes from his Civil War experience.

Other great American artists of the era also acknowledged the legitimacy of war art and devoted considerable canvas to it. Howard Pyle emulated the European masters in the exhaustive research he undertook for his Civil War painting. Accurate in every detail and yet richly evocative, Pyle's works — more specifically *The Battle of Nashville* and *The Charge* — rank among the best of the early depictions of the war.

Students of Pyle's Brandywine School of Art embraced the Civil War as a fit subject for their art. His most famous pupil, N. C.

Wyeth, produced haunting works of both profound beauty and great realism. Wyeth brilliantly juxtaposed the delicacy of nature in bright blue skies and sun-drenched fields with the somber shadows and grey smoke of battle. His best works on the war, *Wilson's Creek* and *The Battle of Westport*, reflect the subtle use of light and color to convey the madness and tragedy of combat. Other, less bellicose paintings, such as his famous study of Stonewall Jackson and the series of works he did for Mary Johnston's popular turn-of-the-century war novels, make use of the Brandywine style to produce paintings both visually compelling and pleasing.

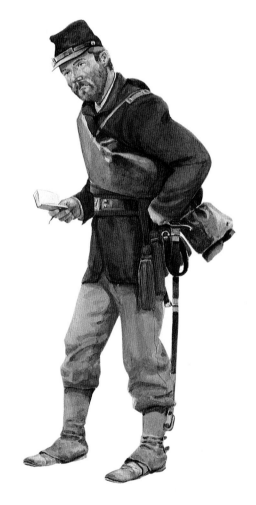

The Artist

Text by Peter Cozzens

Opposite page:
"Fix Bayonets!
Joshua Chamberlain and the
20th Maine at Little Round Top"
1994

It was to the masters from the past — Meissonier, Detaille, Pyle and Wyeth — that Keith Rocco turned for inspiration when, as a young student, he first dedicated himself to historical art. "In the 1960's and 70's, the word at most art schools was anti-realism. Obviously, being a realist, I found that unsettling," recalled Rocco. "What I was being taught in art school didn't help nearly as much as what I learned from studying the works of these artists," he explained. "They not only depicted life, they infused it with an intensity of feeling. All of those artists, whether they were painting a soldier considering the rations in his haversack or the rage of battle, did it in such a way as to make you feel you are right there. Look at their paintings, you can smell the sulphurous smoke from the guns and feel the sun fall across your back. They go beyond a simple rendition of a scene, and I set that as my standard. My goal is to portray history not only with accuracy, but to somehow go beyond that and make it possible for the viewer to experience the sensation of being in the scene itself."

In that, Keith Rocco has succeeded wonderfully. Alone among a legion of artists and illustrators who have paraded the American Civil War on canvas in recent years, Rocco has preserved the finest traditions of the masters. He has evoked their memory while contributing his own unique vision to military art. Like them, Rocco approaches his subjects with a near reverential respect to historical detail. Unlike them, he does not romanticize his subjects. These twin hallmarks of the Rocco style have earned him acclaim as one of the most respected historical artists painting today.

14

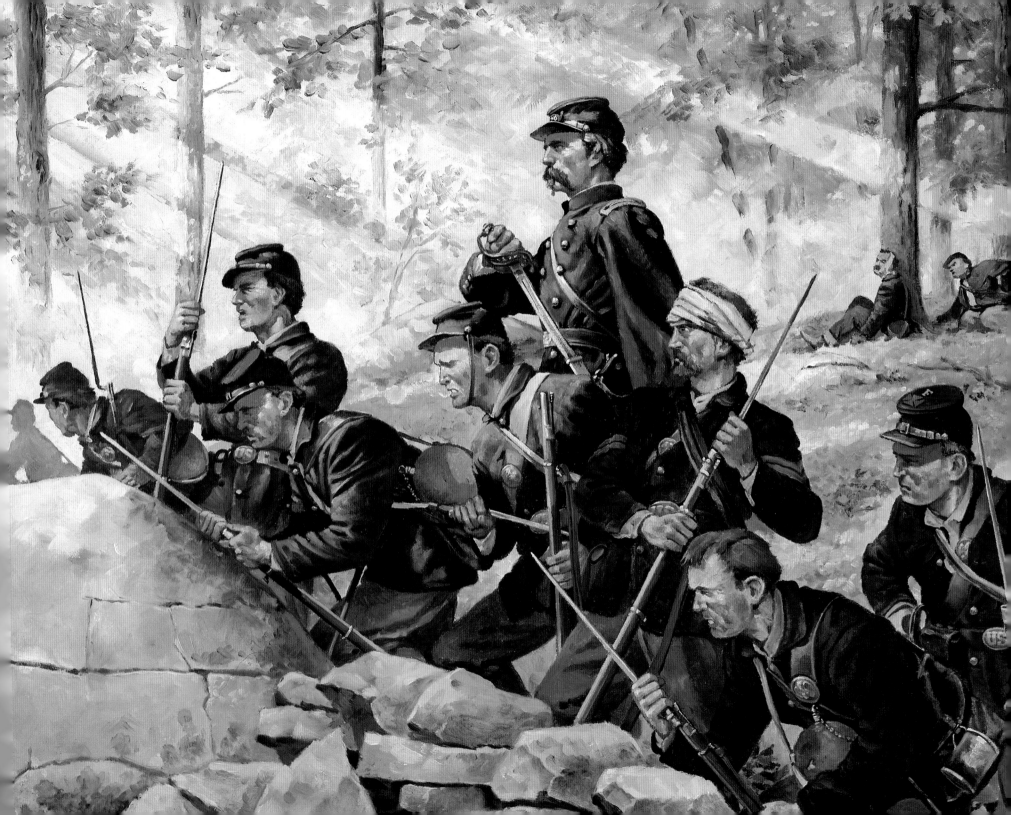

Rocco's passion for history and art began early. As a child he copied pictures from *The Golden Book of the Civil War* and set up toy soldiers to sketch.

At the age of twelve he began what today is an impressive collection of Napoleonic era and American Civil War artifacts. His first purchase, a Civil War cavalry saber, sits in a glass case, with buttons, bullets, a soldier's shaving kit, and a field letter desk. These small and seemingly insignificant articles seed Rocco's imagination.

"There is no better way to understand a period and its people than by holding an arti-fact in your hand," Rocco explains. "This is especially important when you are painting. After all, if you don't know the grade of leather used on a boot, you can't understand how it will fold. Many people don't understand that in addition to the time of day, position of troops, etc., just how crucial these small details are in creating an accurate and realistic scene."

But there is far more to his work. Explains Rocco: "To know and be intimately familiar with equipment, uniforms, and paraphernalia is an absolute necessity. Yet, it is the human drama which is the driving force behind my paintings. In the words of N. C. Wyeth, 'Keep the details true, but subordinate.'"

The amount of research that goes into a sin-gle painting is prodigious. By way of example, study the depiction of the brutal, seesaw fight-ing on Horseshoe Ridge entitled: **To the Last Round: The 21st Ohio at Chickamauga**. Each face turned toward you, from the private crouched in the foreground to the kneeling lieutenant in the background, represents a painstakingly accurate portrayal of a real per-son. The harried looking officer on horseback is Major Arnold McMahan, who had taken charge of the 21st Ohio after the regimental commander was cut down by a sharpshooter's bullet. The young subaltern gazing anxiously at him is Wilson Vance. Just seventeen years old, Vance too found himself unexpectedly

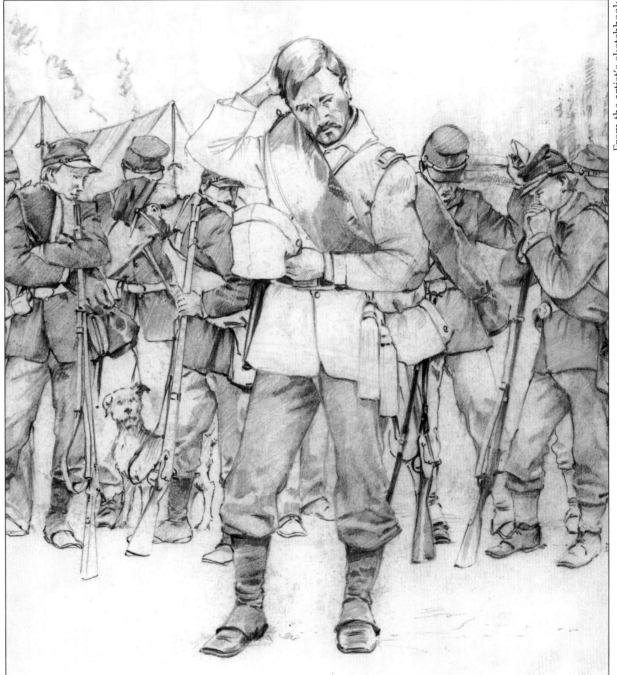

From the artist's sketchbook.

encumbered with the burden of command after the captain of his company was shot in the stomach. In front of Vance is Ordnance Sergeant John Bolton, passing cartridges rummaged from the dead and wounded to men on the firing line.

Their stories are compelling, full of gallantry and sacrifice. But McMahan, Vance, and Bolton are among the legions of soldiers lost to history. Rocco could have painted them from his imagination, and very few would have been the wiser. Instead, he gathered their likenesses from forgotten photographs in small town archives, talked to local historians, and made a study of the unique weapons they

"First Sergeant"
1986

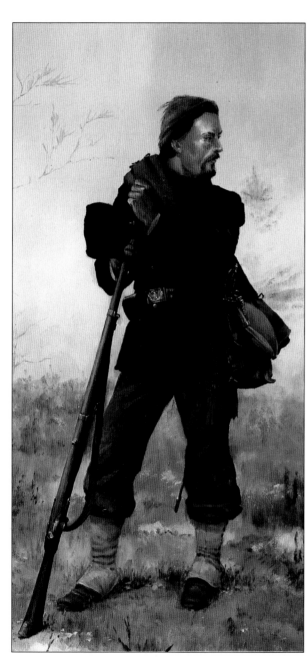

used. All this to ensure a work of unsurpassed authenticity that, married to Rocco's masterful style, emerges on canvas as a moment of true pathos.

It is with men like McMahan, Vance, and Bolton that Rocco identifies, and it is his compassion for their suffering that gives his work their poignancy. "I consider myself a common man," confesses Rocco. "I portray these people who have gone before us as individuals, just like us, put into circumstances beyond their ability to control."

Of his approach to painting, Rocco says: "It is more important to show individuals in uni-

form rather than uniform studies. Thus a single battle scene with two dozen soldiers may present two dozen facial expressions, each a convincing depiction of what the wearer was experiencing. The battle scene is an encapsulation of all these emotions. There's fear. There's courage."

Rocco's efforts have been widely recognized. In 1985, *Uniformes Magazine* proclaimed him an artist "in the tradition of Remington and Detaille." In 1987 his first limited edition print was issued to the market. Since then, *American History Illustrated*, *Civil War Times Illustrated*, *Confederate Veteran*, *America's Civil War*, *Strategy and Tactics*, *Uniformes Magazine*,

Illustration for
Civil War Times Illustrated
1986

19

Opposite page:
**A section of the mural at the
Wisconsin Veterans Museum**
1992

and *Virginia's Civil War* have all featured his work on their covers. His art has graced the dustjackets of numerous books on the Civil War to include *No Better Place to Die, This Terrible Sound,* and *The Shipwreck of Their Hopes.*

Keith Rocco's paintings hang in every major collection of historical art in the United States, and in prestigious institutions abroad. These include the Mellon Foundation, the Pentagon, Gettysburg National Park, the City of Fredericksburg, Virginia, Antietam National Battlefield Park, The Wilderness National Battlefield Park, The National Guard Heritage Collection, The U.S. Army War College, the Atlanta Historical Society, and The Museum of

20

the 24th Foot South Wales Borders.

The marriage of authenticity and human feeling in Rocco's paintings is the secret of his success. It draws people to his work. Jim Kelly, senior exhibit designer at the Milwaukee Public Museum, saw in Rocco's art the qualities desired for three large murals that were to grace the walls of the planned Wisconsin Veterans Museum. Consultant to the project, Kelly observed that historical painters commonly stiffen up when they try to recreate the minute details of earlier eras. Rocco's work is correct in every detail, Kelly told a Chicago Tribune reporter, but it "transcends attention to arms, uniforms, and equipment. He creates

historically convincing work with dramatic emotional style." Rocco earned the commission in 1992.

Today Rocco lives and paints in Virginia's Shenandoah Valley. He can often be found exploring its battlefields, touching the past to better convey it on canvas. Concludes Rocco: "The point is to make history something real, something that carries the viewer out of himself and into another world, where it is his response, literally, that keeps history alive."

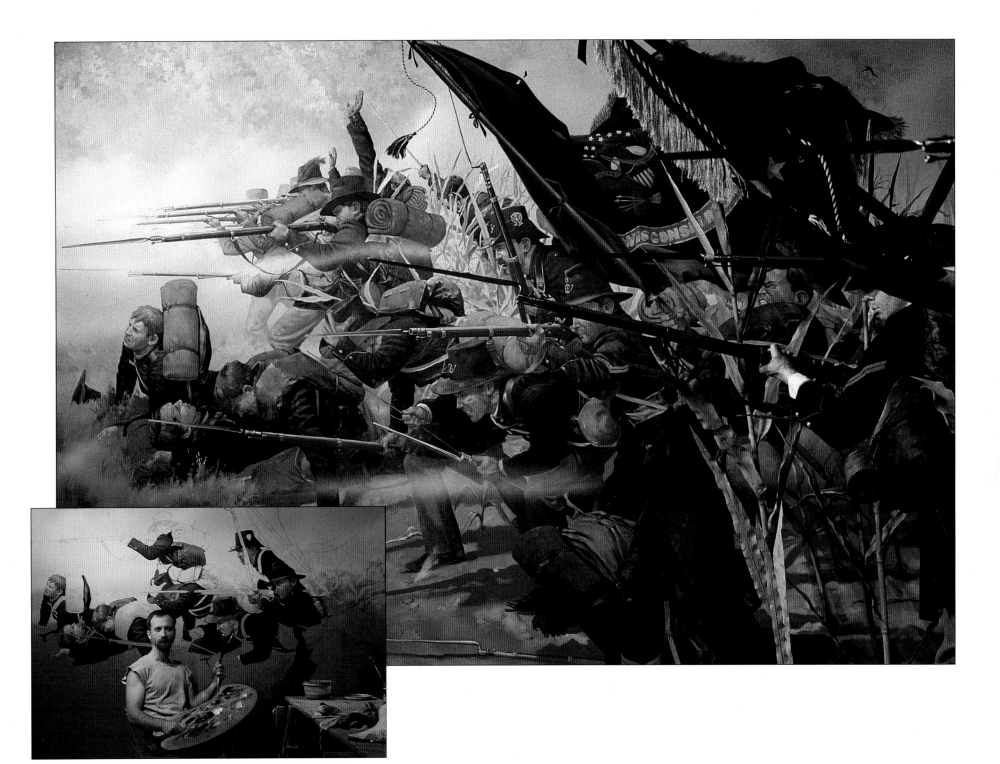

In Camp

Text by D. Scott Hartwig

"The mind was hungry for something . . ."

"Sunday routine in all units was different from that of other days," wrote Bell Wiley in his classic work *Billy Yank.* William G. Stevenson, a Confederate soldier, thought "the idleness of the Sabbath was a great evil, as there was nothing to read, and card-playing and cock-fighting were the chief amusements. This was also our washday and the ration of soap issued for six men was only enough to wash one shirt; hence this was given by lot to one of the mess, and the others were content with the virtue of water alone."

To reduce the soldier's idle time, Sunday in camp was a day of inspection. But for those who were not on duty —such as these men — it was an opportunity for some good natured gossip, or the infrequent luxury of having the regimental barber provide a shave and haircut. Newspapers were particularly sought after, for the soldiers were hungry for news. Others might spend their free time writing a letter home or making an entry in their diary. Novels were popular reading material. John Billings, a Massachusetts artilleryman wrote: "There was no novel so dull, trashy, or sensational as not to find someone so bored with nothing to do that he would wade through it....The mind was hungry for something, and it took husks when it could get nothing better." [William G. Stevenson, *Thirteen Months in the Rebel Army.* John Billings, *Hardtack and Coffee.*]

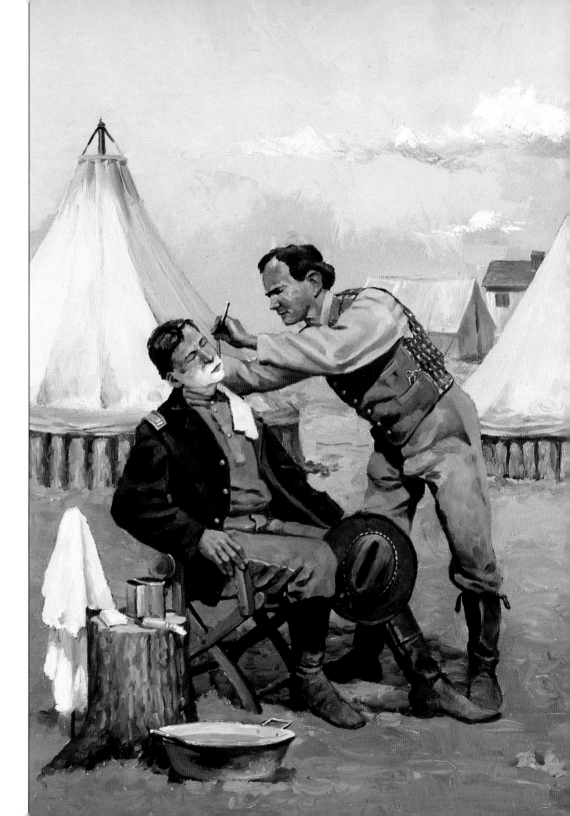

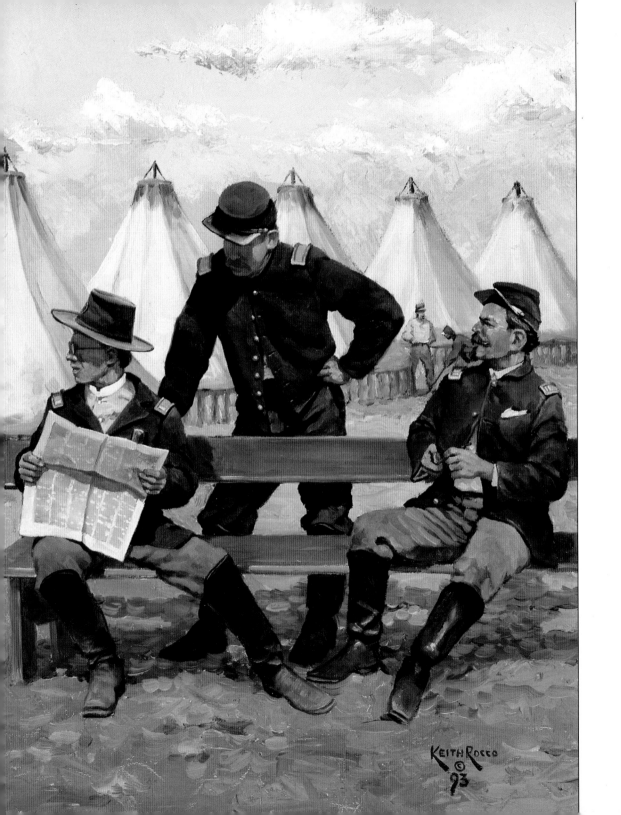

"Sunday Morning in Camp"
1993
25

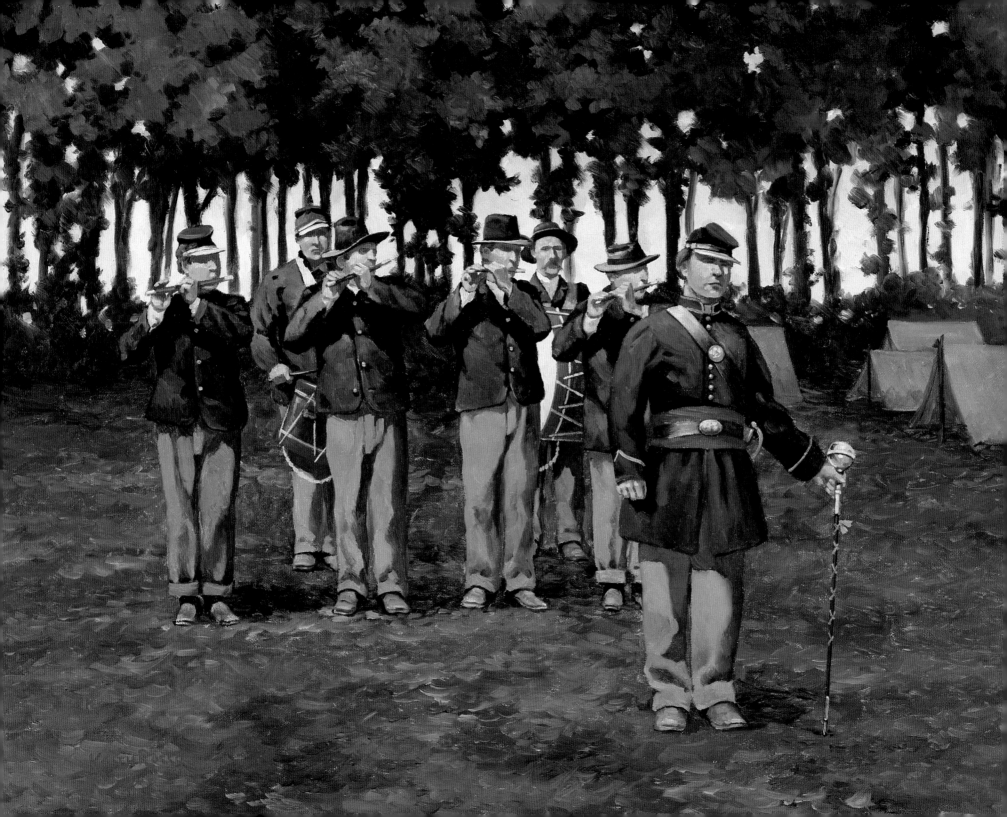

Living by the Fife and the Drum

"The drums of one regiment commence their noisy rataplan, which is taken up by the ear piercing fife and spirit stirring drum of another, til every drum corps of the brigade, with the accompanying bugles and fifes, join in the din, and the morning air is resonant with the rattle of drums, the shrill notes of the fife, or clarion tones of the bugle, sounding reveille," wrote Edwin B. Houghton, of the 17th Maine.

The fifes and drums ruled a soldier's life in camp, from the drummer's first call at 5:45 A.M. until his call for lights out at 9:15 P.M. In an infantry camp there could be a dozen or more daily calls. On the march, the fifes and drums might play a tune to lift spirits or simply to break the monotony.

During their march to battle, Lt. Colonel Rufus Dawes, of the 6th Wisconsin, wrote: "To make a show in the streets of Gettysburg, I brought our drum corps to the front and had the colors unfurled. The drum major, R. N. Smith, had begun to play 'The Campbells are Coming,' and the regiment had closed its ranks and swung into the step, when we first heard the cannon of the enemy...." [Houghton, *The Campaigns of the Seventeenth Maine*. Rufus Dawes, *Service With the Sixth Wisconsin Volunteers*.]

27

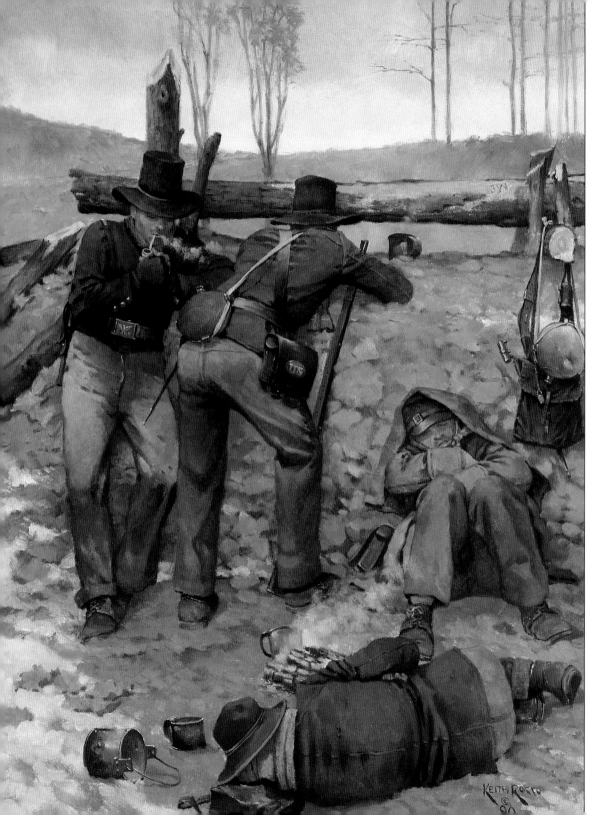

"This duty is not sought . . ."

Upon the outposts often rested the security of the army, for they would sound the first alarm of enemy activity. The soldiers who manned them condemned the duty. If the armies were inactive and the opposing sides had agreed upon an unofficial truce, the enemy was boredom, rain, snow, cold, and mud. Absent a soldiers' truce or during active operations, outpost duty stretched men's nerves to the limit, for death or capture was a constant threat. Rice Bull, a sergeant in the 123rd New York Infantry wrote of outpost duty he pulled during the Atlanta Campaign:

"This duty is not sought; it is nerve wracking, dangerous, and the safety of the Army depended on his vigilance. I had seen more than one man when he returned to the picket line in the morning in such condition physically that he was sent back to the camp. If one wants to know how long a night can be and how black the darkness may become, let him stand some night on the picket line in the face of the enemy. In the rifle pits no one sleeps, talking is in whispers, gun in hand, the men sit or stand peering toward the picket line of the enemy, listening as only men listen when their lives depend on their vigilance. [K. Jack Bauer, ed., *Soldiering: The Civil War Diary of Rice C. Bull*.]

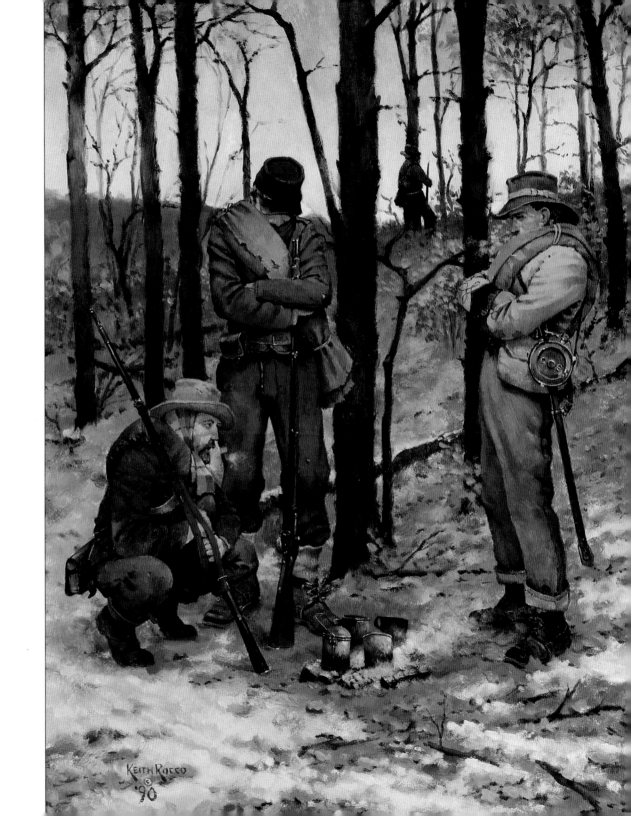

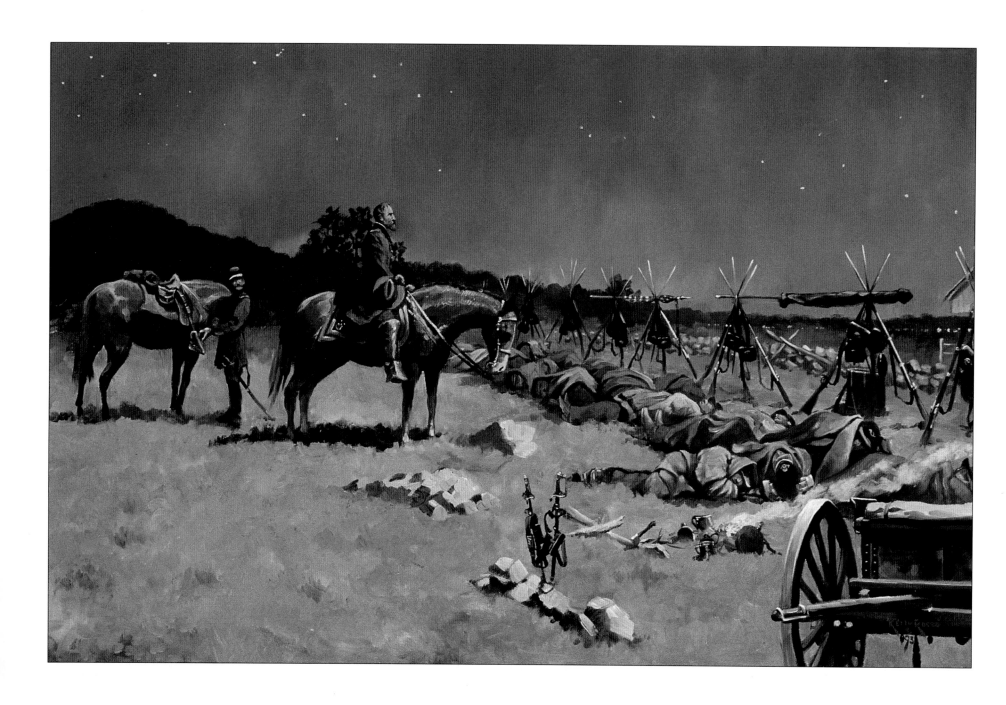

Few Generals in the War Bore a Heavier Burden

According to his son, Major General George G. Meade reached the Gettysburg battlefield "just before midnight" on July 1, 1863. Meade had been selected to command the Army of the Potomac just four days earlier, when Major General Joseph Hooker, the man whom Lee had defeated at Chancellorsville two months earlier, resigned over differences with the War Department. Few generals in the war bore a heavier burden of command than did Meade at Gettysburg. The country looked to him to deliver victory over a Confederate army that had not yet known defeat. If the Army of the Potomac was defeated the consequences to the future of the Union would be grim.

When the battle opened Meade's headquarters was at Taneytown, Maryland, about thirteen miles south of Gettysburg. Rather than gallop off at the first news of fighting around Gettysburg, Meade stayed at Taneytown to better coordinate the movements of his army corps toward the battlefield. Only when he was certain the entire army was responding to the unexpected clash at Gettysburg did he transfer headquarters to the battlefield.

Meade rode to the gatehouse of the Evergreen Cemetery where he found six or seven generals, including Oliver Howard, Henry Slocum, and Daniel Sickles. All of them agreed that the terrain south of Gettysburg offered advantages. General Sickles was heard to say; "It is a good place to fight from, general!" To which Meade responded:"I am glad to hear you say so, gentlemen, for it is too late to leave it." After this brief conversation Meade walked across the Baltimore Pike to East Cemetery Hill and gazed over the landscape his army would fight upon. It was too dark to make out much, but the campfires of the enemy could be clearly seen to the north and west. Meade returned to the gatehouse to attend to preparations for operations on July 2nd. Before dawn, he rode with General Howard, artillery commander General Henry Hunt, and Captain William H. Paine, an engineer, to examine the lines on the left.

The Bivouac captures Meade on the northern end of Cemetery Ridge, near the farm of a free black man named Abraham Brian, gazing west toward Seminary Ridge. In front of Meade, the line of stacked muskets and sleeping soldiers belong to Brigadier General John Robinson's 2nd Division, 1st Army Corps, which had suffered dreadful casualties in the first day of fighting. Captain Paine, adjusting his saddle, casts a glance at Meade. The entire army, indeed the entire Union, was doing the same. All eyes were upon the grizzled, tired general, taking measure of him. No one had yet been able to defeat Lee in battle. Could Meade? The pressure upon him was immense, and has been borne by few generals in American military history. His position was one of uncomfortable loneliness, for upon his decisions the lives of thousands of his men depended, and the future of a nation hung in balance. [George G. Meade Jr., *Life and Letters of George G. Meade*. Edwin Coddington, *The Gettysburg Campaign.*]

Opposite page:
"The Bivouac: Meade at Gettysburg"
1993

This page:
"A Short Rest"
1986

On The March

Text by D. Scott Hartwig

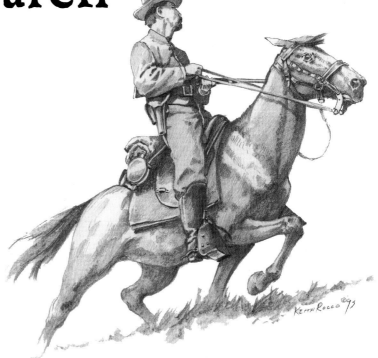

"It is quite an honor to be a Bugler . . ."

The drum was most closely associated with the infantry at the start of the Civil War, while the bugle has been identified principally as a tool of the cavalry. As the war progressed the value of the bugle as a means of communication for infantry formations was appreciated. It was light and less cumbersome than the infantry drum, and the bugler could also carry a musket, something the drummer could not do. The bugle was particularly effective for communicating commands to skirmishers, who fought in more dispersed formations. Dan O. Mason, who served for a time as the bugler in the 6th Vermont Infantry, wrote that "it is quite an honor to be Bugler for a regiment." He went on to describe his duties:

"When an army is advancing through the enemies country it is frequently necessary to send out a portion or a whole Reg to search the woods a little in advance of the main army so as not to meet with a sudden surprise from the enemy....the Bugler sounds the call used to represent the command. the Capts have to be familiar enough with the calls so they can tell one from an other." [Dan O. Mason to Harriet, Feb. 5, 1862, quoted in B. A. Botkin, *A Civil War Treasury*.]

In the western theater of the war, with its larger and heavily timbered battlefields, the infantry bugle was frequently employed to

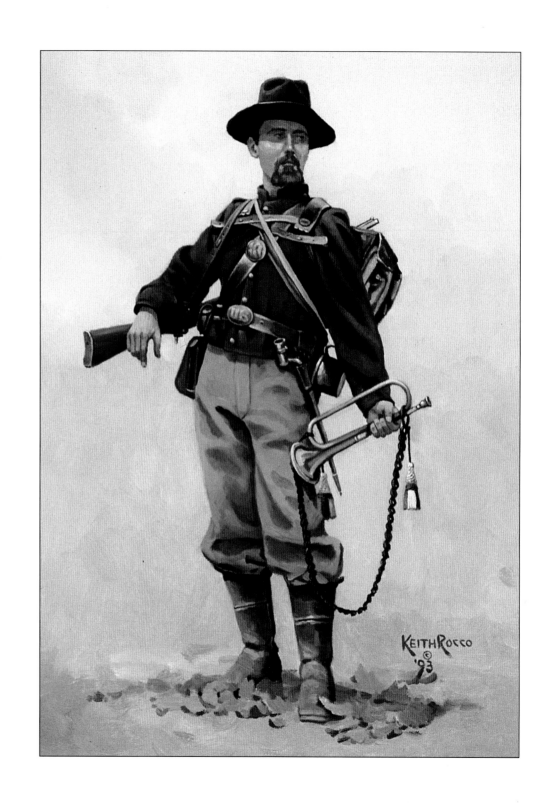

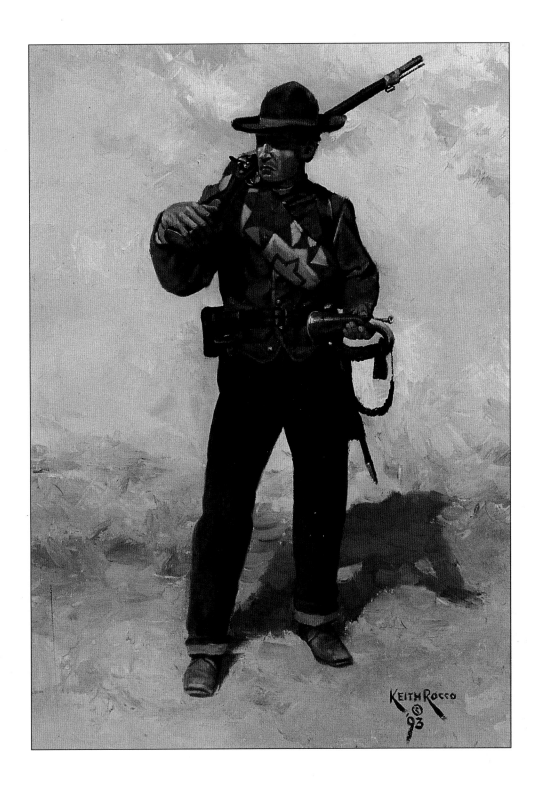

Opposite page:
"Federal Infantry Bugler"
1993

This page:
"Confederate Infantry Bugler"
1993

communicate commands to troops in action. 1st Lieutenant Alexis Cope, of the 15th Ohio Infantry, described an incident during the battle of Pickett's Mill, on May 27, 1864, where bugle calls served warning to the Confederates of impending attack:

"Our expedition, as we understood, was intended to surprise the enemy and yet, strange to relate, our brigade commander [Col. Gibson] decided to have all orders given by the bugle. This gave the enemy immediate and continuous notice of our movement every step of the way. To the men in the ranks who quickly comprehended the purpose of our movement, this use of the bugle was universally condemned. More than one officer and man exclaimed, 'If we are expected to surprise the enemy, why don't they stop those damned bugles?'" [Alexis Cope, quoted in Larry M. Strayer and Richard A. Baumgartner, ed., *Echoes of Battle: The Atlanta Campaign*.]

35

Opposite page:
"Confederate Reconnaissance"
1990

This page:
"Skirmishing"
1990

It Was Dangerous Work

Often the only method an officer had of determining the enemy's position, movements or intentions was to go forward in person to the picket or skirmish line, or, on rare occasions, beyond it, to study the situation with the aid of his field glasses. In the painting on page 37 a Confederate line officer and first sergeant have crept forward to get a closer look at the enemy. It was dangerous work, particularly if the enemy was on the alert and had posted sharpshooters or pickets. Sharpshooters were quick to catch the glint of sun off an officer's field glasses, or the tin of a canteen, or cup, and bring the reconnaissance to a swift and deadly conclusion with a bullet. Even darkness did not diminish the danger.

2nd Lieutenant Chesley Moseman, of the 59th Illinois Infantry, wrote in his journal during the Atlanta Campaign: "But there is little sport in visiting the pickets on the line after midnight in the darkness, as an officer has to do, to see that they are watchful and learn of any new developments that may have been noticed by them. Especially as one may lose direction and stray outside our own line and be shot by our own men." [Arnold Gates, ed., *The Rough Side of War: The Civil War Journal of Chesley A. Moseman.*]

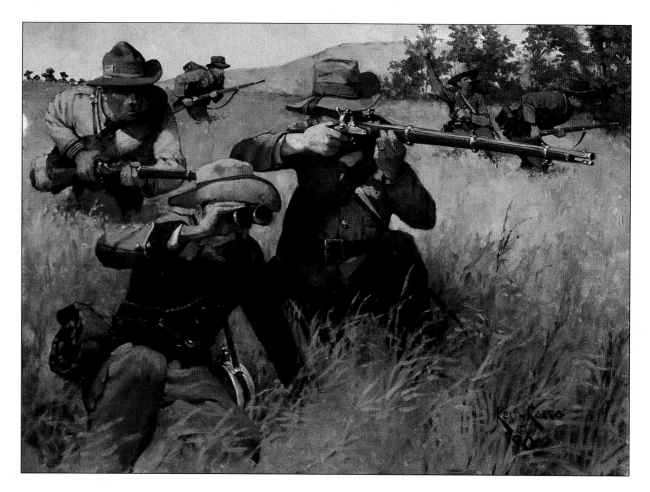

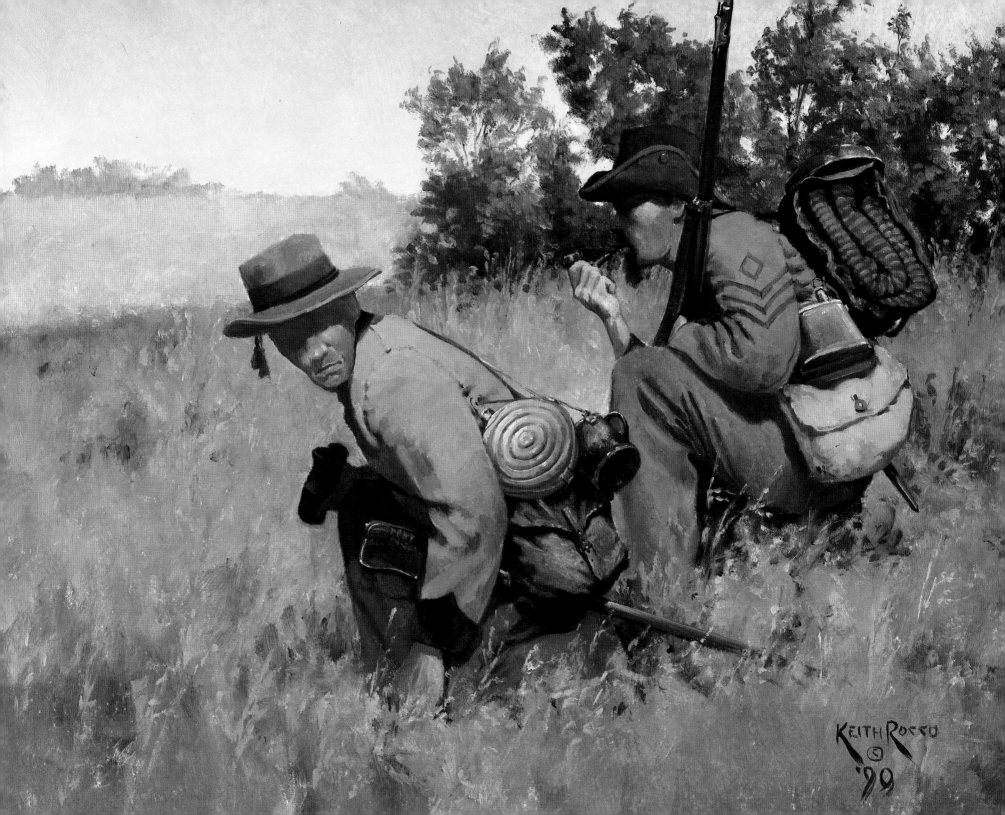

"... when it comes, all will do their duty."

A late winter snow blankets Virginia's Shenandoah Valley, the breadbasket for Robert E. Lee's Army of Northern Virginia. It is 1864 and the commencement of the bloody spring campaign is two months away. Lee's skillful generalship spared the Valley any major Union incursions in 1863. But a new Union general commands the Federal armies now, Ulysses S. Grant, and he intends to challenge the Valley defenders.

For the moment, the weather is the Confederate soldier's nemesis. Ted Barclay, of the famous Stonewall Brigade, wrote on March 27th: "We stand on picket again day after tomorrow and as it has been snowing and snowing for a day or so, a walk of ten miles through the slush will not be very pleasant." But Barclay and his comrades know that with the coming of spring the Federal armies will be on the move. His attitude upon this is that of a veteran:

"You see we are as big cowards as ever. This thing of soldiers being anxious to engage the enemy, or as our papers term it 'spoiling for a fight,' is all fudge; we are never anxious, but when it comes, all will do their duty." [Charles W. Turner, ed., *Letters From the Stonewall Brigade.*]

Opposite page:
"Confederate Officers in the Valley"
1993

This page:
"Confederate Study"
1994

38

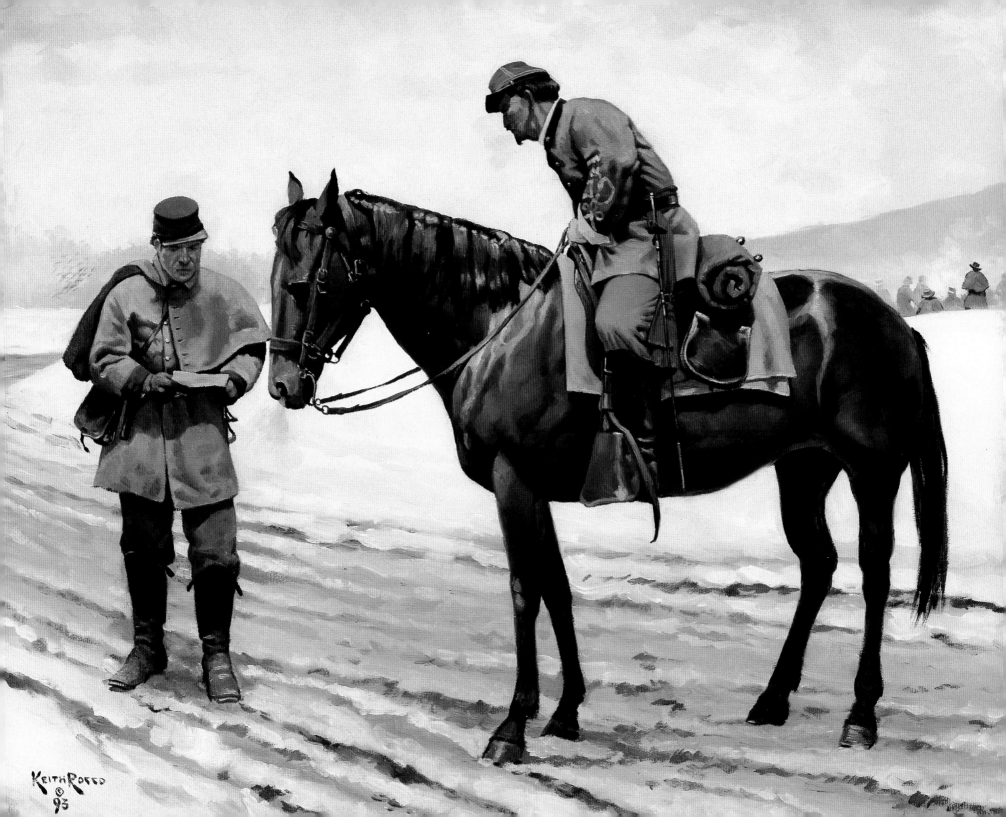

Opposite page:
"Cavalry Reconnaissance"
1985

This page:
"Confederate Cavalry Bugler"
1985

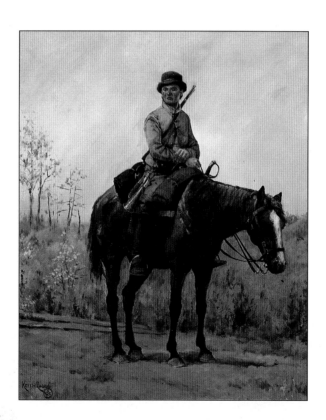

An Occupation of Constant Danger and Arduous Work

The rifled weaponry of the Civil War permanently changed the employment of cavalry in warfare. They were no longer the heavy shock troops they had been for centuries. Instead they rendered their most important service before and after the great battles, scouting and reconnoitering. Their mobility also made them ideal to raid enemy communications and supply lines, or to screen the front and flanks of an army on the move. In the painting on page 41 a cavalry reconnaissance patrol stops to speak with an infantry picket. The infantry often derided the cavalry with jests of "who ever saw a dead cavalryman?"

Continued on Page 43

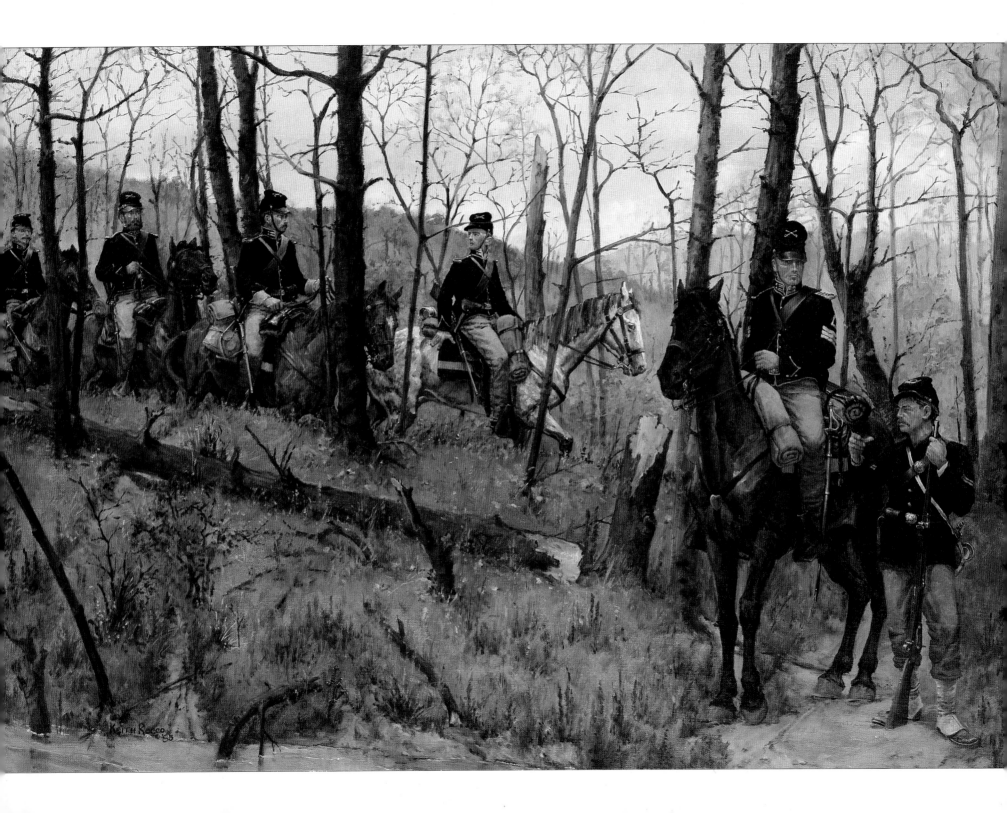

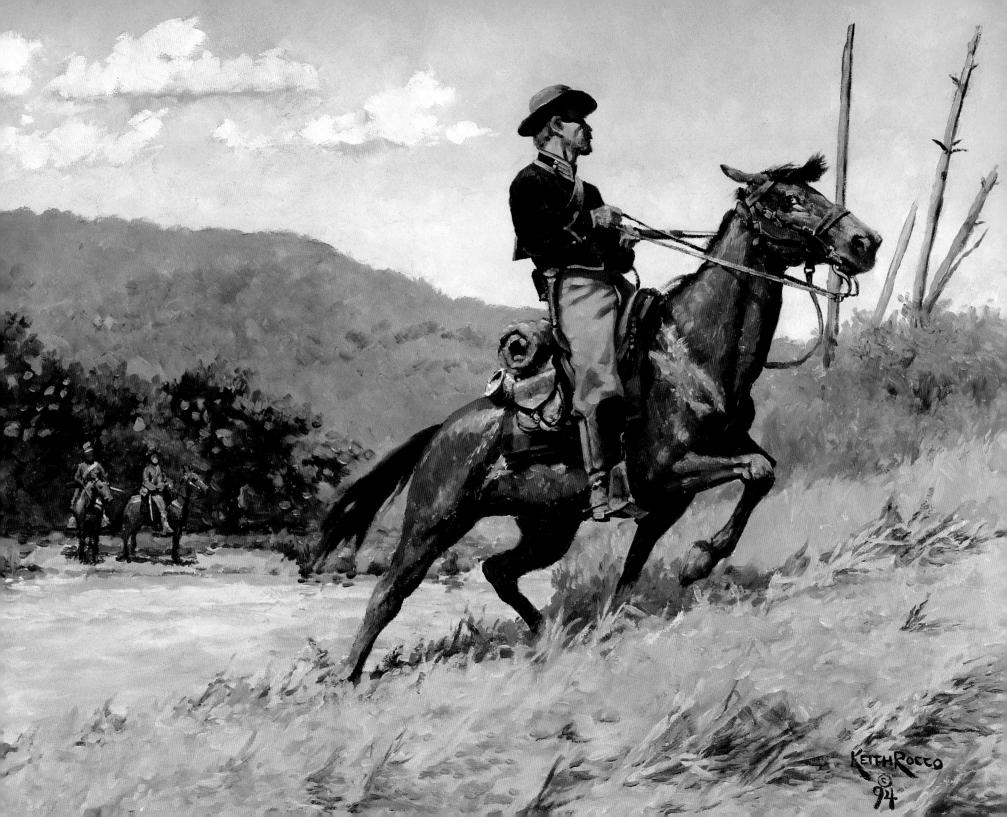

But the duty of a cavalryman while on campaign was to maintain contact with the enemy, an occupation of constant danger and arduous work. One cavalryman, who served in the 10th New York Cavalry, recalled of a ten-day raid his unit participated in: "Then I learned what fatigue and hunger meant. Ten days — ten long days and nights of weariness."

Another Union cavalryman wrote that his regiment participated in a raid that covered eighty miles in thirty hours. He described the toll it exacted upon the troopers: "In consequence of the jaded condition of our horses it was necessary to make frequent halts...when a halt was ordered, some men would dismount, and, sinking to the ground through exhaustion, would quickly fall asleep. With the utmost difficulty they were aroused by their comrades when the column advanced. Calling them by their names, though we did it with mouth to ear, and with all our might, made no impression upon them. In many instances we were compelled to take hold of them, roll them over, tumble them about, and pound them, before we could make them realize that the proper time for rest and sleep had not yet come." [N. D. Preston, *History of the Tenth New York Cavalry*. William Glazier, *Three Years in the Federal Cavalry*.]

From the artist's sketchbook.

43

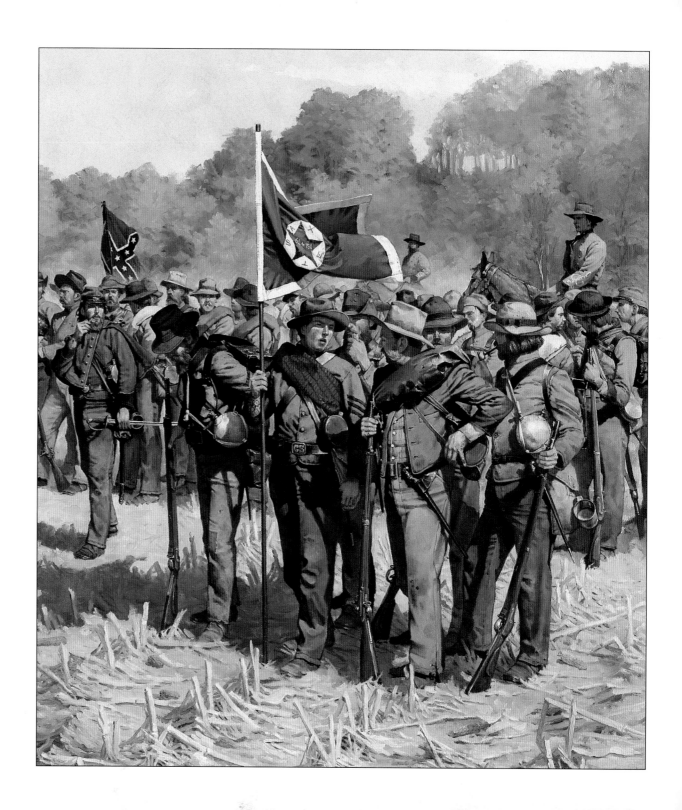

"The Color Guard of the 6th and 15th Texas Consolidated"
1991
44

It Was a Position of Immense Danger in Battle

The colors of a Civil War regiment were more than a guide or means of communication. They were the symbol of the regiment, which its men pledged to defend with their lives. Their capture in battle was one of the greatest dishonors a regiment could suffer. It was the duty of the color guard to protect them.

The guard consisted of a color sergeant, who bore the regimental colors, and between five to eight corporals. Their post was in the front rank of the center of the regiment. It was a position of immense danger in battle, for the colors always drew the heaviest fire. A few shrank from the danger. Following the Battle of Antietam, the lieutenant colonel of the 11th Connecticut, which had been under particularly heavy fire, reported that the bearer of the national flag "refused to advance and could not be induced to do so." Only the bravest could be entrusted with these sacred emblems.

The colors themselves bore the scars of the battles they had passed through. Often, bullets, shells and weather would render them little more than tattered rags hanging from a battered flag staff. In most cases a new stand of colors would be issued.

The unit depicted here, the consolidated 6th and 15th Texas, carried four different flags during the war. Their first was surrendered at Fort Hindman, Arkansas, when it capitulated to Union forces in January, 1863. After their parole the regiments were assigned to Patrick Cleburne's division in the Army of Tennessee. They adopted the distinctive blue "full moon" battle flags of William Hardee's corps, within that army. This flag was replaced with a new set of standards in early 1864, which was carried throughout the Atlanta Campaign. In the autumn of 1864 this flag was replaced with one containing a plain white circular disk, decorated with the "lone star."

This is the flag depicted in **The Color Guard**. It was the last flag of the combined regiments and was carried during the dismal Tennessee campaign of November and December, 1864. At the end of the war it was returned to Texas, a symbol of the men who had fought courageously under its folds.

"Confederate Color Bearer"
1994

Opposite page:
"Thomas, The Rock of Chickamauga"
1989

This page:
"The Veteran"
1993

"... as we lay still and wait our turn."

To be designated a reserve was a mixed blessing. On the one hand the unit generally enjoyed the protection of some form of cover. On the other hand the reserve had to endure the tension of waiting, often under a fire they were unable to return.

During the engagement at Lookout Mountain, Tennessee, on November 24, 1863, Chesley Moseman of the 59th Illinois Volunteers described the experience of his regiment while in reserve: "We were in reserve....Firing was not very heavy....But the Rebels on top the mountain annoy us very much by shooting at us when we can't well reply. It began to rain, a kind of mist moistening us. We lay still till 4 P.M. without actively taking part with Rebel sharpshooters on top taking deliberate shots at us....The Rebels have cannon on top and fire it often. It makes a thundering racket up there in the heavens from 800 to 1,000 feet above us, but we are so nearly under it that the canister whistles harmlessly over our heads, occasionally dropping into the river below. But these dirty devils with the muskets reach us, knocking dirt out at our feet or whistling by us as we lay still and wait our turn."

In Reserve on pages 48-49 depicts the preparation to the storming of Lookout Mountain by Union forces under Major General Joseph Hooker. Few battles of the war rivaled this battlefield for its magnificent sweep and panorama. But the view of the Union soldier, whose job it was to storm the heights, was limited by a heavy mist that blanketed the slope. "We can't see very far as the mist is so heavy, almost a fog," wrote Moseman, while his regiment lay in reserve. While Union batteries pound away at the

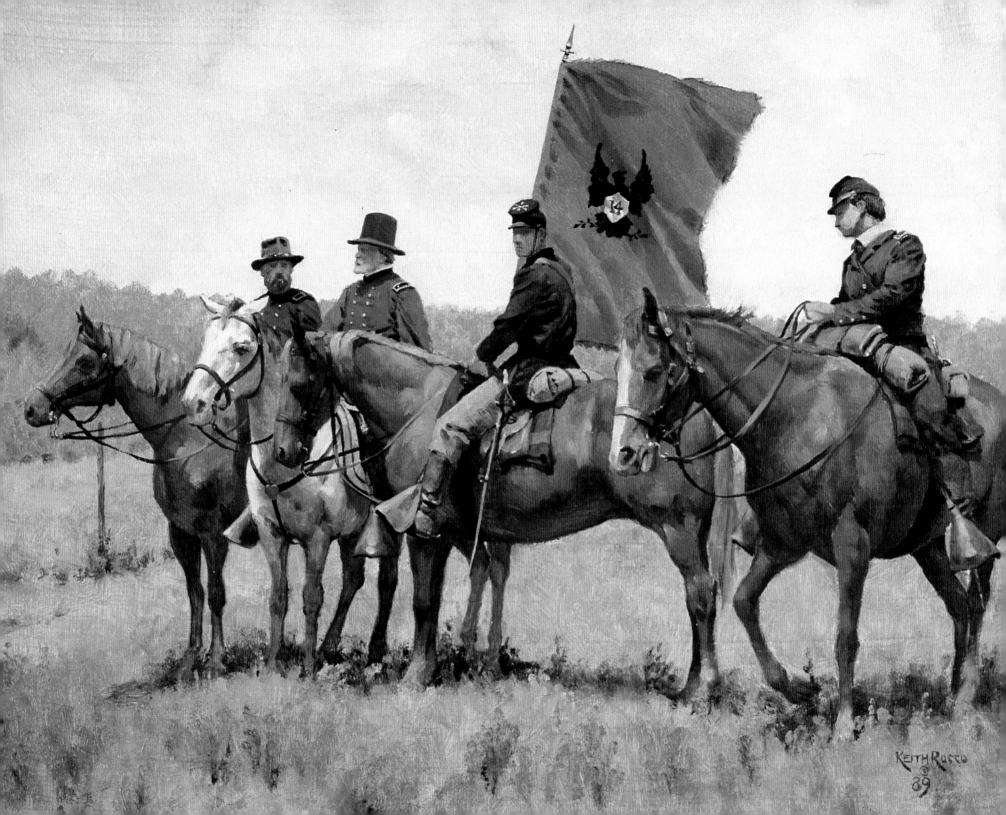

"In Reserve: The Bombardment of Lookout Mountain"
1994

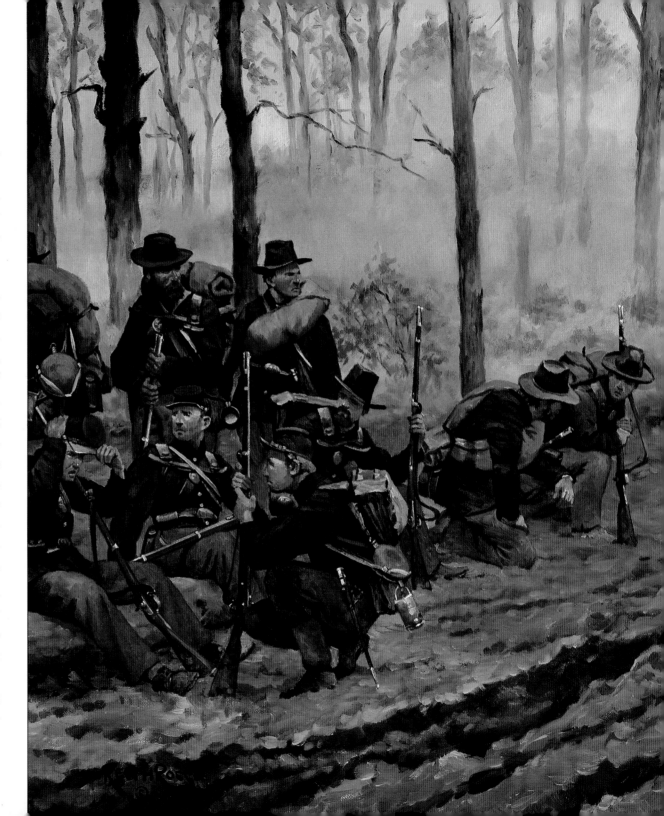

mountain in the distance, Missouri and Illinois soldiers of Brigadier General Charles R. Woods' brigade [Woods appears on the brown horse] of Osterhaus' division, 15th Army Corps, await orders to advance in the foreground.

It was nearly noon before Woods' men advanced to take their part in the fray. "We commenced the ascent of the mountain with but little opposition, capturing everything in our path," wrote Colonel Thomas Curley, of the 27th Missouri, and "soon the Stars and Stripes were floating from the highest point overlooking Chattanooga." Woods was pleased with his brigade's performance in the "Battle Above the Clouds," as it became known. He wrote, "I cannot speak too highly of the conduct of the officers and men under my command during the engagement. They moved forward to the attack with an energy that overcame all opposition, and they held every inch of ground gained with a tenacity which foiled the enemy in every attempt to dislodge them." [Arnold Gabes, ed., *The Rough Side of War: Civil War Journal of Chesley A. Moseman, 1st Lieutenant, Company D, 59th Illinois Volunteer Infantry Regiment.* U.S. War Department, *The Official Records of the Union and Confederate Armies in the War of the Rebellion.*]

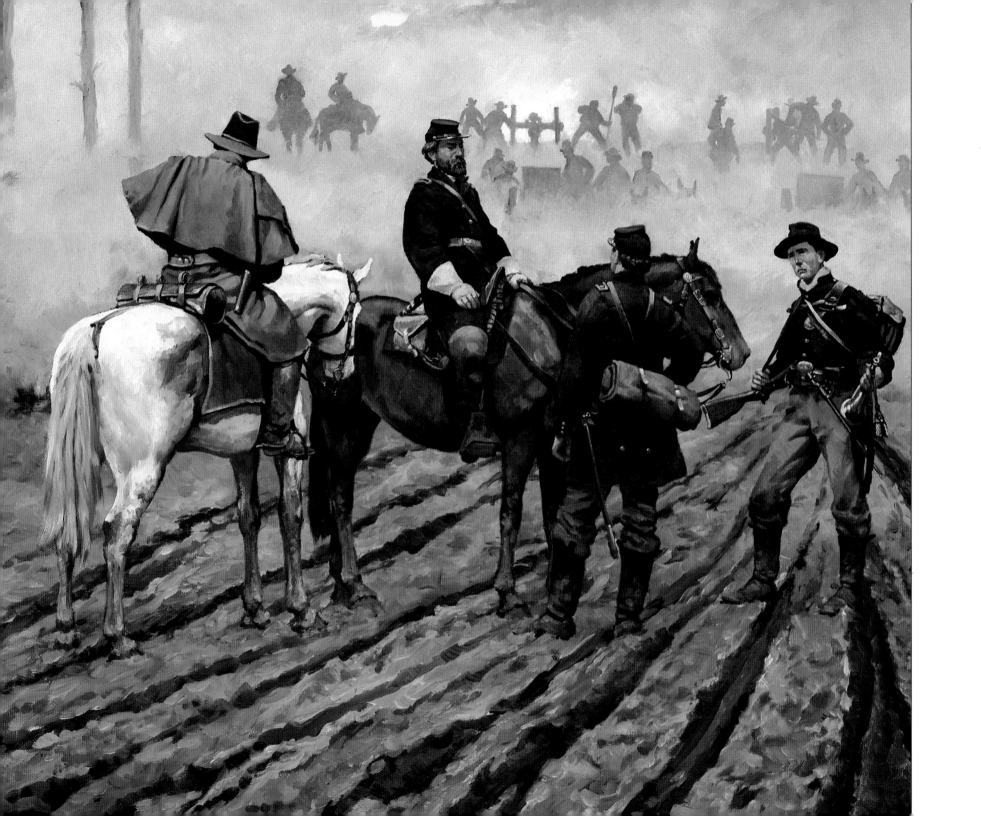

The Battle Cry

Text by D. Scott Hartwig and Peter Cozzens

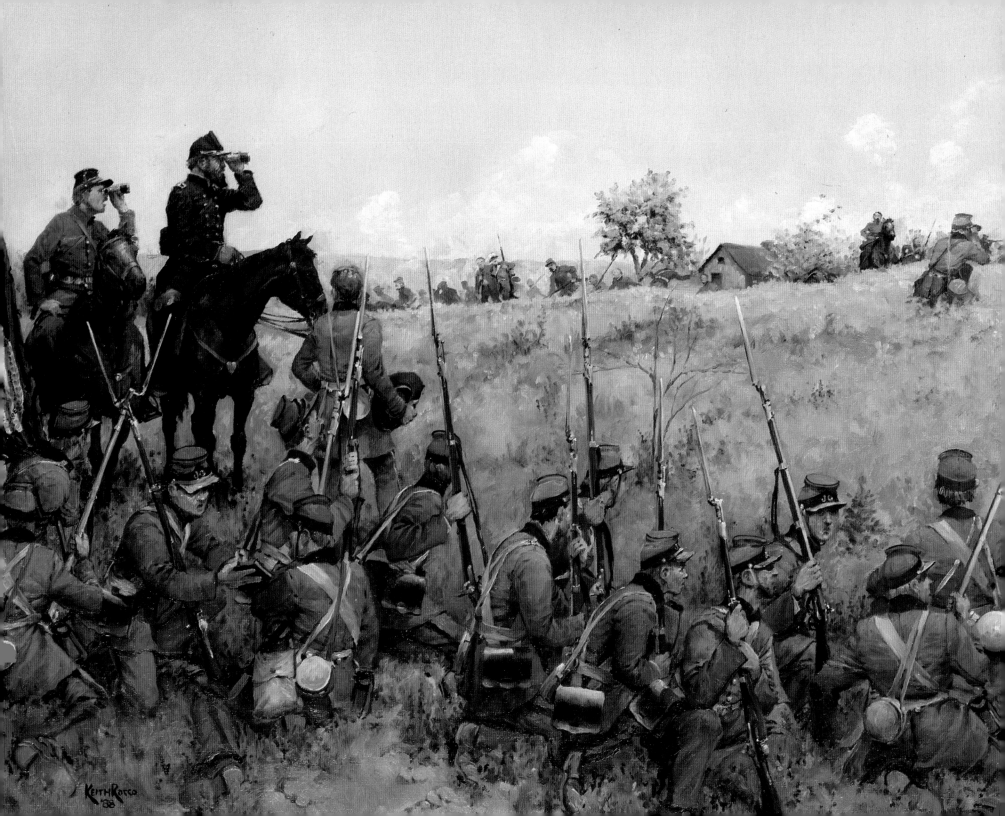

"Rally behind the Virginians!"

By 2 P.M. of July 21, 1861, victory seemed within the grasp of Major General Irwin McDowell's Union Army on the battlefield of Manassas. His brigades had turned the left of Confederate General Pierre G. T. Beauregard's line sending Evans', Bartow's and Bee's brigades tumbling back toward Henry House Hill to avoid destruction. If this hill could be taken the battle would be won. The Union brigades of Porter, Franklin, Sherman, and Willcox pressed forward on the heels of the retreating Confederates to secure it.

Unseen by the advancing Federals, a fresh line of Confederate infantry awaited their approach. Brigadier General Thomas J. Jackson's Virginia brigade, 2,600 strong, had arrived upon Henry House Hill around 11:30 A.M. Gaining the important high ground, Jackson had deployed his five regiments on the reverse slope of the hill, where they would be out of sight of Federal batteries. Jackson's men crouched and listened to the sounds of battle in their front.

To strengthen his position Jackson assembled all the artillery within reach. This amounted to fourteen guns of four different batteries.

The gun crews were soon in action, punishing the advancing Federal brigades with a terrible fire. The critical moment of the Battle of Manassas – captured in Keith Rocco's **The Stonewall: Jackson at Manassas** – was at hand.

Jackson has not made his legendary stand. The battle is undecided. Behind Jackson, who is wearing his blue U.S. Army frock coat and scanning the approaching Union brigades through field glasses, crouch men of the 4th Virginia Infantry. Rocco captures the tension in their ranks. Some men strain to catch a glimpse of what is in front; others hand their personal effects to a comrade. In their front the Confederate batteries pound the advancing Union ranks. The gun draws its ammunition from an improvised piece of equipment — a farm wagon. Beyond the gun the roof of the widow Judith C. Henry's house can be seen. Men of Bee's, Bartow's, and Evans' brigades, dispirited and disorganized, appear on the crest, hurrying to escape the pursuit of the Federal infantry.

The appearance of Bee's, Bartow's and Evans' men warned Jackson that the enemy would soon be at hand. He turned to an aide and stated: "Tell the colonel of this brigade that the enemy are advancing: when their heads are seen above the hill, let the whole line rise, move forward with a shout, and truth to the bayonet. I'm tired of this long range work." Moments later, Colonel Bee rode up to Jackson and cried out, "General, they are beating us back!" To which Jackson calmly replied, "Then, sir, we will give them the bayonet!" Encouraged by Jackson's resolution, Bee rode to his command and shouted:"Look! There is Jackson standing like a stone wall! Rally behind the Virginians!"

Bee's words helped create an American legend. A desperate battle was soon joined in which Bee was mortally wounded. But Jackson's brigade formed the stabilizing force that helped hold the Confederate line together, and although the battle on Henry House Hill ebbed and flowed, the momentum began to shift to the Confederate army' favor. By nightfall, the Union army would be routed and in retreat toward Washington. The Confederate army had won the first major battle of the Civil War and Jackson had earned a nickname that would endure: "Stonewall." [William C. Davis, *Battle at Bull Run*. John Hennessy, *First Battle of Manassas*.]

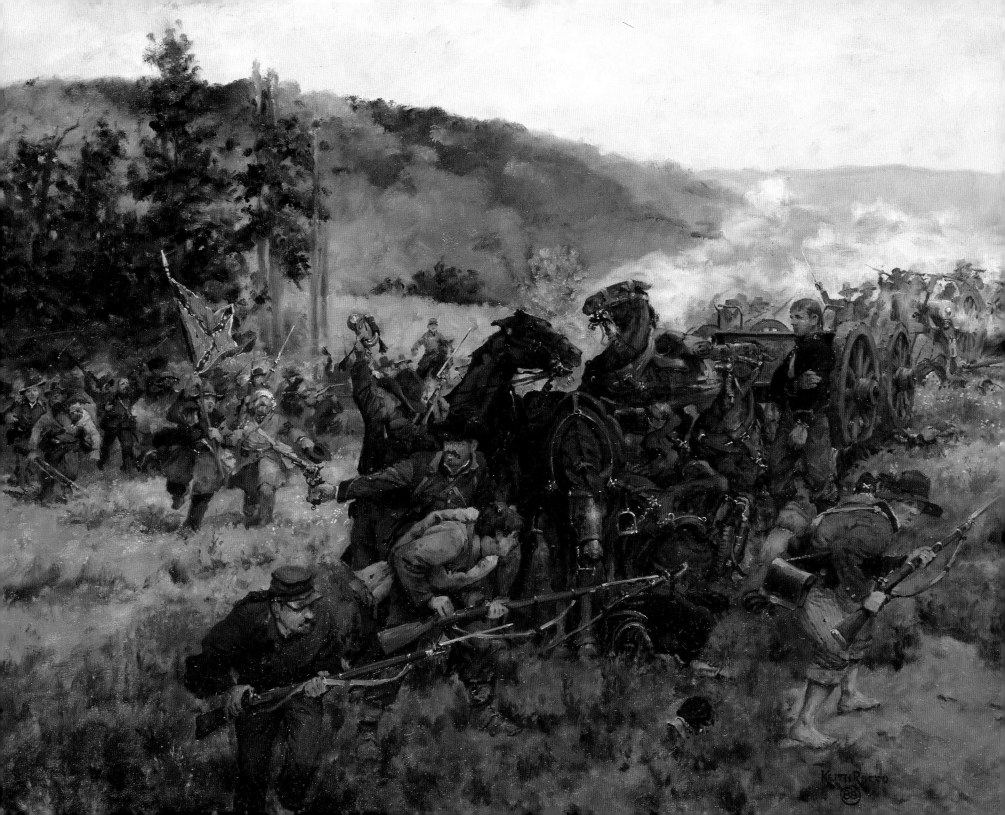

"Surprise had aided us . . ."

During the Battle of Port Republic on June 9, 1862, three guns of Captain Joseph C. Clark's Battery E, 4th U. S. Artillery, were left in an exposed position when they were pounced upon by Brigadier General Richard Taylor's Louisiana Brigade. Taylor later described the fierce struggle that is captured on canvas by Keith Rocco:

"With a rush and shout the gorge was passed and we were in the battery. Surprise had aided us, but the enemy's infantry rallied in a moment and drove us out. We returned, to be driven a second time. The riflemen on the slope worried us no little, and two companies of the 9th regiment were sent up the gorge to gain ground above and dislodge them, which was accomplished. The fighting in and around the battery was hand to hand, and many fell from bayonet wounds. Even the artillerymen used their rammers in a way not laid down in the Manual, and died at their guns. As Conan said to the devil, 'Twas claw for claw.' I called for Hays, but he, the promptest of men, and his splendid regiment, could not be found. Something unexpected had occurred, but there was no time for speculation. With a desperate rally, in which I believe the drummer-boys shared, we carried the battery for the third time, and held it." [Richard Taylor, *Destruction and Reconstruction.*]

From the artist's sketchbook.

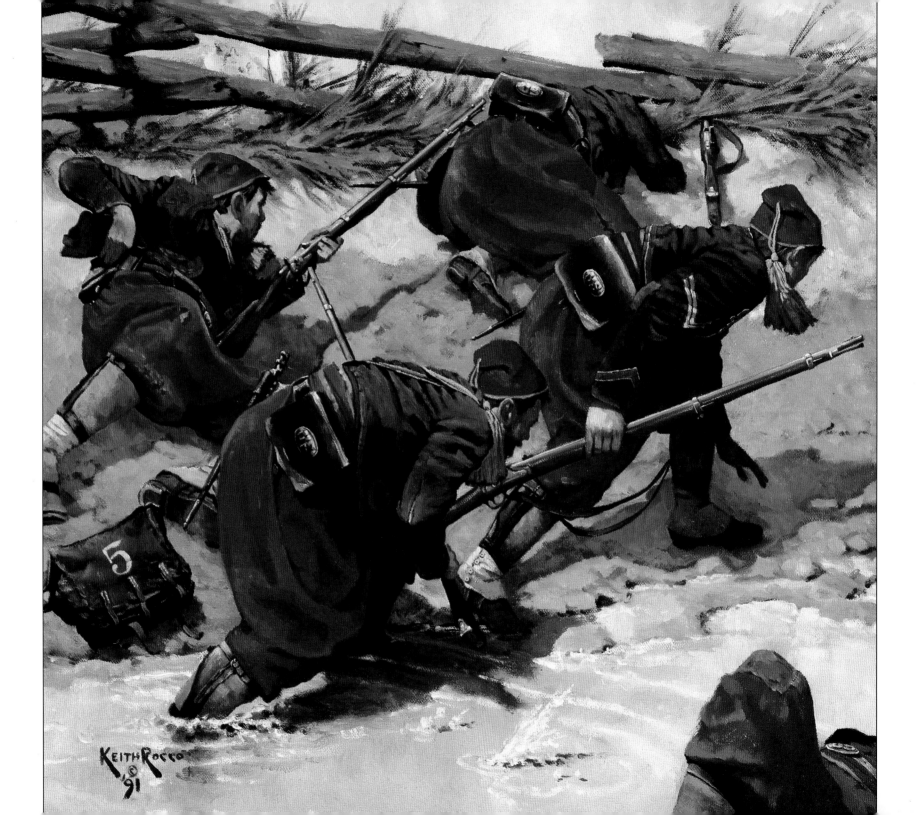

"Now, men, your time has come . . ."

The scene on page 56 illustrates an incident at the Battle of Gaines' Mill, on June 27, 1862. Lieutenant Col. Hiram Duryee 5th New York had been sent by brigade commander Colonel Gouverneur K. Warren "to a cut in a road that led along at right angles to the former position."

Along the top of the bank was a brush fence, through which, recalled regimental historian Alfred Davenport, "they could watch any movements of the enemy if they came out into the open ground." The enemy, troops of General A. P. Hill's famous Light Division soon made their appearance, moving at the double-quick. Davenport recalled:

"After they were well out in the field, Colonel Duryee cried, 'Now, men, your time has come; get up and do your duty!' The regiment jumped up as one man, and down went the fence on the bank in front, and the order was given to left wheel....They immediately fell flat on the ground, but suffered severely in turn, from the enemy's fire, but then loaded again quickly and jumped up and gave them another volley; this was repeated four or five times, the enemy closing up and then made a charge on Company I. Captain Partridge, before this, had given them orders when they fell back, to join the regiment according to their best judgement if they got scattered, either on the left or the right of it, whichever was the nearest point. He had just given the order, `Skirmishers, retreat!' when Sergeant Strachan saw him lift his hand to his side; he jumped for him, but the Captain fell, opening his mouth as if to speak, out of which rushed a stream of blood; he was shot through the heart."

By the end of the day, out of 450 effectives, the 5th had lost 38 killed, 110 wounded, and 15 missing. [Alfred Davenport, *Camp and Field Life of the Fifth New York Volunteer Infantry*.]

"I never want to fight there again."

The Miller cornfield at Antietam. Few places in America have known the mad violence that swept back and forth through this gentle field of corn on September 17, 1862. Full and nearly ready for harvest, it offered the skirmishers of Confederate Colonel Marcellus Douglas' Georgia brigade excellent concealment. When daylight broke, these skirmishers, in company strength, were the only Confederate troops in the field. The main body of Douglas' brigade took position in a pasture immediately south of the cornfield. There they piled some fence rails for protection and waited for the Union onslaught.

The Federals were on the move by daylight. Advancing directly toward Miller's farm were the 2nd and 6th Wisconsin Infantry regiments of Brigadier General John Gibbon's brigade. It was known as the "Black Hat Brigade," for part of the uniform Gibbon had issued to his brigade included the regulation army black Hardee Hat.

"The command was under fire from its front immediately upon deployment," recalled the 6th's colonel, Edward Bragg. Confederate artillery shelled the two regiments and others moving nearby. The second shell fired found its mark in the 6th's ranks, killing and wounding 13 men.

But the column pressed on and, wrote Colonel Bragg, "having a sniff of blood in their nostrils that morning, swept like a storm cloud, over skirmishers and everything opposing." Douglas' skirmishers, after firing upon the advancing Union force, melted back through the cornstalks. The 6th and 2nd plunged into Miller's corn.

"The corn stalks were from seven to eight feet high," recalled Major Rufus Dawes of the 6th, "and while we were in the cornfield we could neither see nor be seen." The line pressed on, shouldering its way through the dense corn. Dawes remembered the instant captured on canvas by Rocco; when the 6th and 2nd emerged from the corn: ·

"As we appeared at the edge of the corn, a long line of men in butternut and gray rose up from the ground. Simultaneously, the hostile battle lines opened a tremendous fire upon each other. Men, I can not say fell; they were knocked out of the ranks by dozens. But we jumped over the fence and pushed on, loading, firing, and shouting as we advanced. There was, on the part of the men, great hysterical excitement, eagerness to go forward, and a reckless disregard of life, of every thing but victory."

Before the sun set that day, Miller's cornfield would change hands six times and be trampled into a bloody, body-strewn shambles. Nine months later, during the Gettysburg campaign, Rufus Dawes would read a prediction in the newspaper of another battle at Antietam. "I hope not," he wrote; "I never want to fight there again. The flower of our regiment were slaughtered in that terrible corn-field. I dread the thought of the place." [Rufus Dawes, *Service With the Sixth Wisconsin Volunteers.*]

58

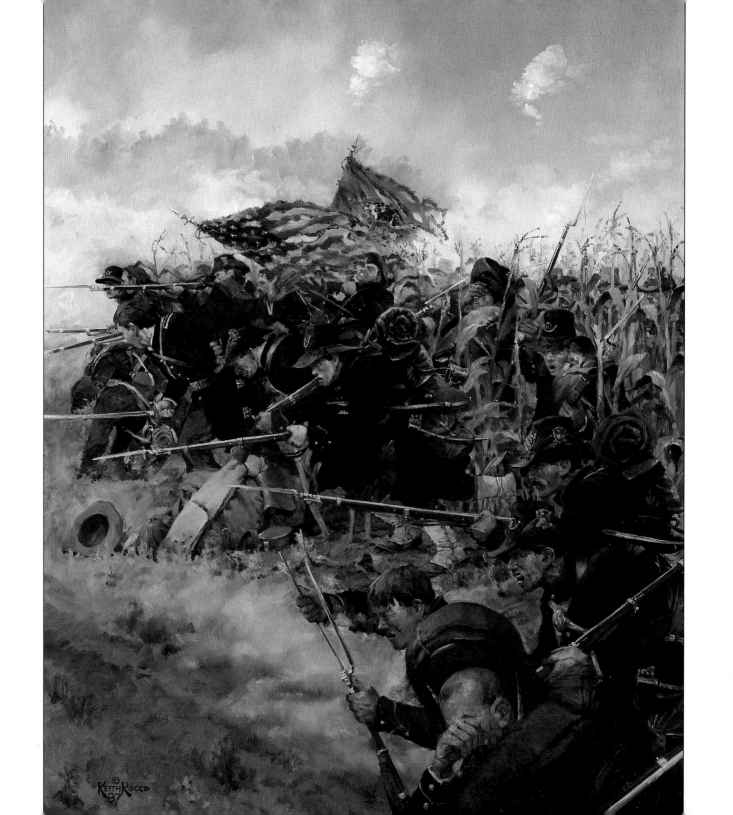

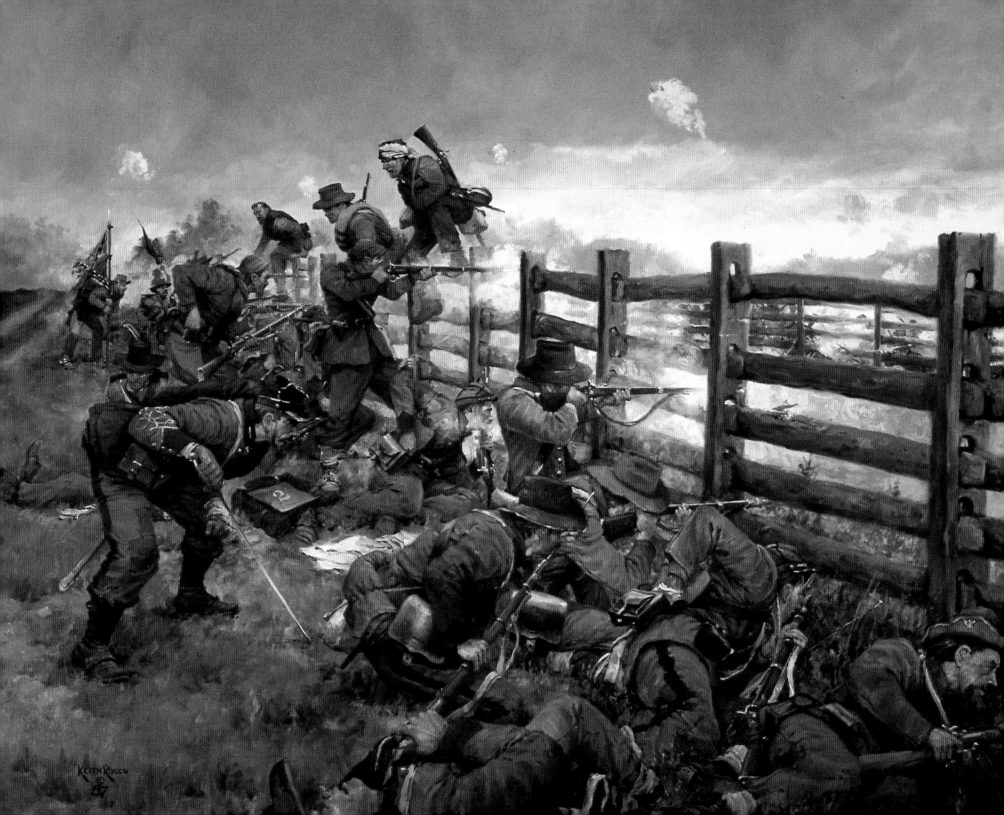

"... at a range of scarcely thirty yards."

September 17, 1862. Sharpsburg, Maryland. Stonewall Jackson's command on the Confederate left had been subjected to a furious attack by the Union 1st Army Corps. In the pasture south of the David Miller cornfield, Alexander Lawton's Georgia Brigade was being decimated by the advance of the Union brigades of Gibbon and Phelps.

To forestall a collapse, Confederate Brigadier General William Starke led his Louisiana brigade and Colonel James W. Jackson's Alabama and Virginia brigade from their reserve position in the West Woods to the fences lining the Hagerstown Pike. Here they traded fire with Gibbon's and Phelps' men at a range of scarcely thirty yards. It was eye to eye combat.

Starke's counterattack stemmed the Union tide for a few moments, but his men were caught in a converging fire. Gibbon's and Phelps' men poured a heavy musketry into their front, while Battery B, 4th U. S. Artillery, positioned in the Miller barnyard to the north, fired case shot into their flank, and the 7th Wisconsin and 19th Indiana, in the West Woods, blazed away at Starke's rear.

Starke was mortally wounded. His men were forced to retreat to the shelter of the West Woods. Starke's brigade lost 81 killed, 189 wounded and 17 missing; a fraction of the terrible toll the fighting along the Hagerstown Pike would exact before nightfall.

"The battle raged horribly . . ."

The first three hours of the Battle of Antietam had seen some of the most desperate fighting of the war. Stonewall Jackson had stopped the attacks of the Union 1st and 12th Corps, but the cost had been high, and he was compelled to call for reinforcements.

The situation was serious. The East Woods was in Federal hands, as was the northern end of the West Woods. Elements of the 12th Corps had seized a foothold near the Dunker Church. At 9 A.M. Major General Edwin Sumner, commanding the Union 2nd Corps, appeared at the head of Brigadier General John Sedgwick's 5,400-man division.

Sumner did not pause to reconnoiter. He ordered Sedgwick to deploy his division into three parallel lines of battle, with a mere fifty yards between each brigade line. Then Sumner ordered the division forward.

The West Woods was held by Early's brigade of Confederate infantry and a handful of men from General J. R. Jones's division. If the West Woods were lost, Lee's position at Sharpsburg would be in jeopardy.

Lee responded to Jackson's call for help by drawing upon his reserve: Major General Lafayette McLaws' division, which had reached the field that morning after a night march from Harper's Ferry.

McLaws' men moved swiftly to the left. As they swept toward the West Woods, they saw Federal troops advancing toward them. It was Sedgwick's division. "I told General Kershaw whose brigade was on the right, that we must get to the woods in front of us before the enemy got full possession and to do this...he must double quick there and come up. I gave the signal by waving my handkerchief for the movement to commence and in a few minutes we were engaged."

McLaws' brigades were joined by G. T. Anderson's brigade of Georgians, which had been sent to reinforce the shattered left. McLaws' and Anderson's advance was nearly perpendicular to that of Sedgwick. Sedgwick's brigades had entered the West Woods and were skirmishing with Jackson's men. Their left flank was completely exposed. The division remained in three parallel brigade lines; so close together that maneuver to meet a flank attack was impossible.

McLaws and Anderson struck Sedgwick's left flank hard. **Counterattack: The West Woods** captures the moment when Brigadier General Joseph B. Kershaw's South Carolina brigade burst upon it. Robert W. Shand, of the 2nd South Carolina, described the ensuing struggle:

"The battle raged horribly, both sides firing as rapidly as they could load their muzzle-loading rifles. Men were falling all around me, and I could see numbers of the enemy falling in my front. There would be volleys and more scattered firing....Officers were yelling to the men, and men shouting. Groans were heard but unheeded....Lieut. Lorick jumped to the front, called to his men to follow, waved his sword, and fell badly wounded in the face, disfigured for life....I thought I would make sure that I had killed a man, so I aimed at the one who stood third from the color bearer in my front and pulled trigger. He threw up his arms and fell to the ground....Many had fallen on both sides...when the Union Army in our front wavered. We yelled and charged and they broke and fled." [Robert Shand, *Reminiscences*.]

In twenty minutes of fighting, Sedgwick's division was routed from the West Woods with the loss of 2,200 men – the heaviest sustained by any Union division at Antietam. This action turned the tide of battle on the Confederate left. [Lafayette McLaws, "The Capture of Harper's Ferry," *Philadelphia Weekly Press*.]

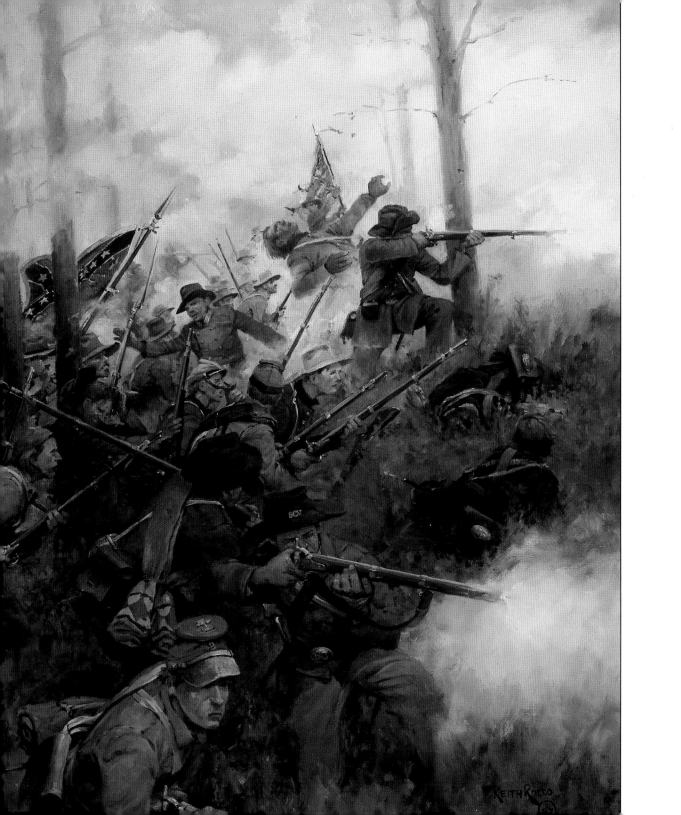

**"Counterattack:
The West Woods"**
1987

63

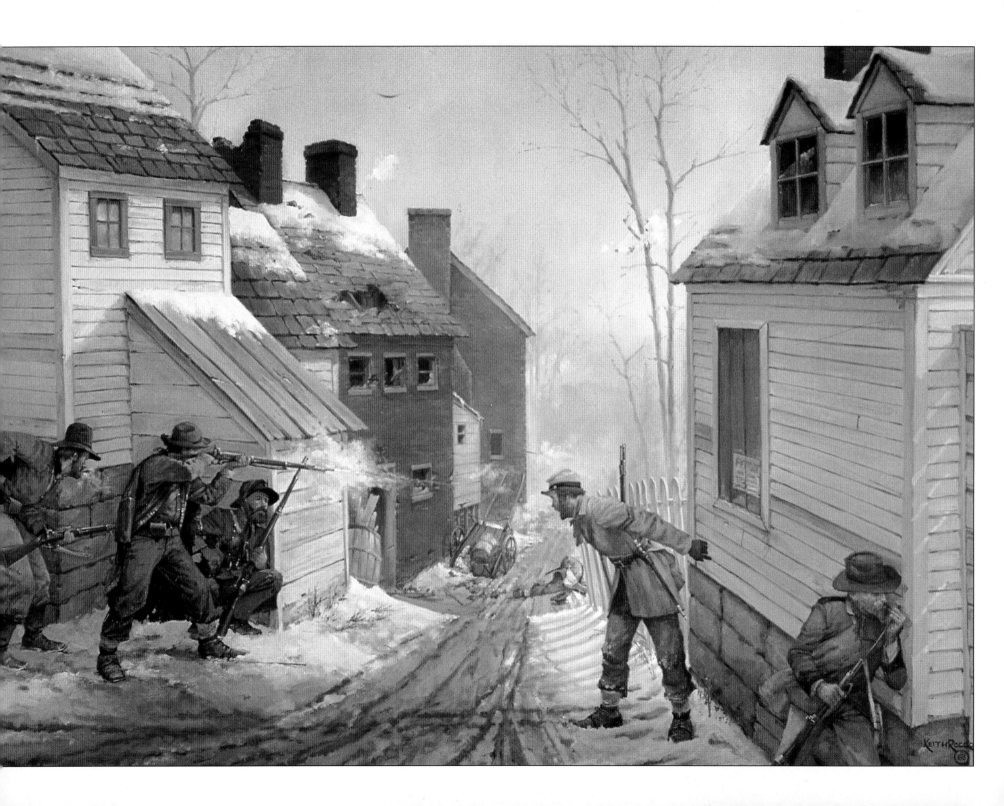

Every Effort to Lay the Pontoons . . . Was Frustrated

December 10, 1862. Fredericksburg, Virginia. For nearly one week the Union Army of the Potomac and Confederate Army of Northern Virginia had faced one another across the Rappahannock River. The weather had turned bitterly cold.

Burnside decided to conduct a frontal attack against Lee. To get at Lee's army, he first had to lay a series of pontoon bridges across the Rappahannock. The Federals assumed the crossing would be easy. They had lined the high ground on the north bank of the river with 147 pieces of artillery, dominating Fredericksburg and every river crossing site.

Lee realized he could not prevent a crossing below Fredericksburg, but could make it difficult for the Union troops to cross opposite the city, where defenders could conceal themselves in the buildings. Several days before Burnside made his decision to assail Lee, the Mississippi brigade of Brigadier General William Barksdale was ordered to occupy the town. Barksdale had his men dig rifle pits along the river's edge.

During the night of December 10, Burnside's army began to move. "We could distinctly hear the noise of launching the boats and laying down the planks," recalled Captain James Dinkens, of the 18th Mississippi. By 3 A.M. Barksdale's men could hear the Union engineers talking softly. Barksdale cautioned his men to remain quiet and not open fire until the enemy approached the southern shore.

At 4 A.M., the crack of Barksdale's muskets broke the stillness. A heavy fog obscured the Federal engineers, and the Rebels aimed by sound. Their fire forced the bridge-builders to abandon their work. Each time they returned, Barksdale's riflemen sent them stumbling for cover.

Every effort to lay the pontoons opposite Fredericksburg that morning was frustrated. At 10 A.M. Burnside ordered his artillery to shell the city and drive out the Confederate defenders. James Dinkens recalled the bombardment:

"The bombardment was kept up for nearly two hours....Hundreds of tons of iron were hurled against the place, and nothing in war can exceed the horror of that time. The deafening roar of cannon and bursting shells, falling walls and chimneys, brick and timbers flying through the air, houses set on fire, the smoke adding to the already heavy fog, the bursting of flames through the house tops, made a scene which has no parallel in history."

Burnside's engineers attempted to renew their bridge-laying efforts. Barksdale's men were largely untouched by the storm of shells directed upon the town, and they quickly drove the Federals back.

It was apparent that only infantry could dislodge the Confederates from Fredericksburg. Troops were loaded into pontoon boats and rowed across. A lodgement was gained and Barksdale's men along the river bank fell back into the shattered city. The Union infantry dashed forward to clear Fredericksburg of Confederates. Slowly and stubbornly, Barksdale's men gave ground. Not until after dark did the Mississippian retire his command from the town to the main Confederate line. For nearly an entire day, a brigade of 1,600 men had held up the crossing of two entire Union army corps. It was a remarkable feat of arms. James Dinkens recalled: "When the Mississippians, who had thus far stood the brunt of the attack, marched over the ridge to rest, carrying their guns at a right shoulder, cheer after cheer rang out from along the line." [James Dinkens, "Griffith-Barksdale-Humphrey Brigade," *Southern Historical Society Papers*.]

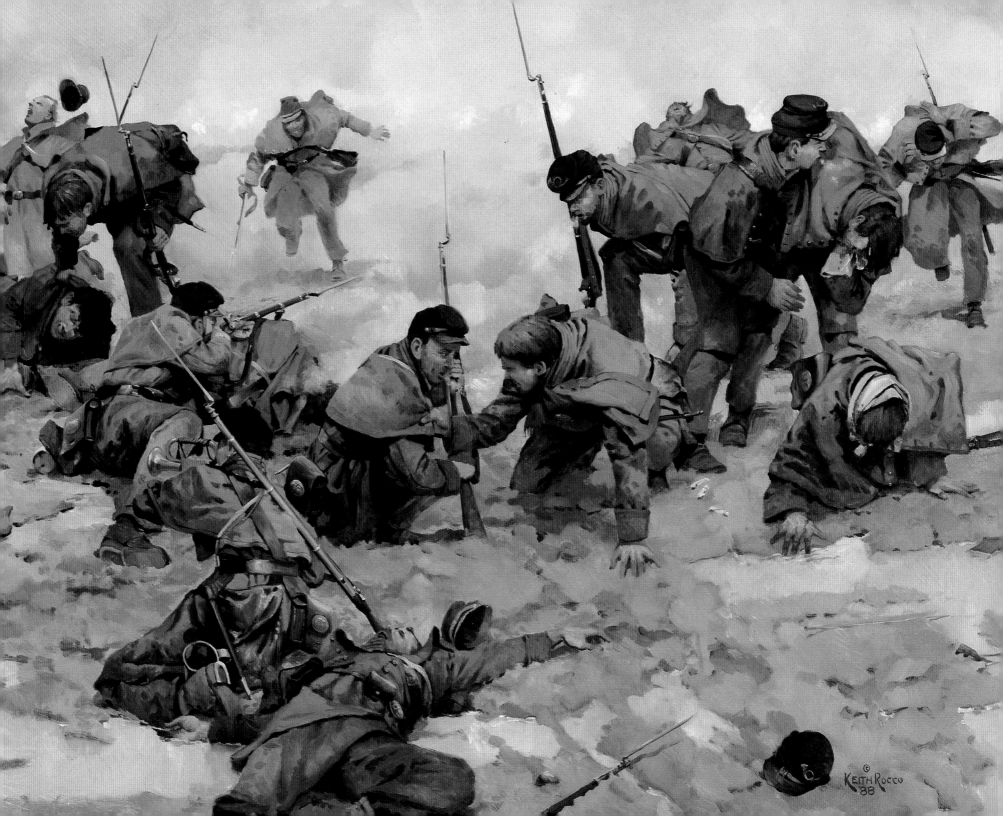

"... the consuming passion ... is to get out of the way."

The painting on page 66 captures the stark reality of Civil War combat. A Union unit is retreating under fire from their Confederate enemy. "I nevertheless found war an ugly business, the faces of men awaiting and dreading death not beautiful to behold," wrote a French soldier in 1914. It was no different in 1861-1865.

While most military art of the Civil War has dwelled upon the heroic, this scene illustrates the true face of Civil War combat. There are no histrionics, but there is bravery, fear, agony, panic, anger, and death – sudden and anonymous.

David Thompson, a private in the 9th New York Infantry, described a similar moment at Antietam:

"One of the enemy's grape-shot had plowed a groove in the skull of a young fellow and had cut his overcoat from his shoulders. He never stirred from his position, but lay there face downwards a dreadful spectacle. A moment after, I heard a man cursing a comrade for lying on him heavily. He was cursing a dying man. As the range grew better, the firing became more rapid, the situation desperate and exasperating to the last degree. Human nature was on the rack, and there burst forth from it the most vehement, terrible swearing I have ever heard. Certainly the joy of conflict was not ours that day. The suspense was only for a moment, however, for the order to charge came just after. Whether the regiment was thrown into disorder or not, I never knew. I only remember that as we rose and started all the fire that had been held back so long was loosed. In a second the air was full of the hiss of bullets and the hurtle of grape-shot. The mental strain was so great that I saw at that moment the singular effect mentioned, I think, in the life of Goethe on a similar occasion — the whole landscape turned slightly red.

"We heard all through the war that the army 'was eager to be led against the enemy.' It must have been so, and editors confirmed it. But when you came to hunt for this particular itch, it was always the next regiment that had it. The truth is, when bullets are whacking against tree-trunks and solid shot are cracking skulls like egg-shells, the consuming passion in the breast of the average man is to get out of the way." [David Thompson, "With Burnside at Antietam," *Battles and Leaders of the Civil War*.]

"...unable to withstand the shock of our charge..."

The northward movement of Robert E. Lee's Army of Northern Virginia during the Gettysburg campaign precipitated a running series of cavalry clashes as Union cavalry probed for the main body of Lee's army. One such occurred at Middleburg, Virginia, on June 17, 1863. Colonel Alfred N. Duffie's 1st Rhode Island Cavalry, 275 strong, had been ordered to march west to the town of Middleburg, situated along the Ashby Gap Turnpike.

It was the duty of the Confederate cavalry, under Major General J. E. B. Stuart, to screen Lee's army from probes such as Duffie's. It so happened that Stuart and his staff were in Middleburg on the late afternoon of the 17th when Duffie's Rhode Islanders came calling. Stuart and his staff made a rapid and not altogether dignified retreat from the town to avoid capture. Duffie moved into town unopposed, dismounted his troopers and put them to work barricading the streets for the anticipated Confederate counterattack.

Meanwhile, Stuart had galloped west from town where he met General Beverly Robertson's brigade. Stuart ordered that the town be retaken immediately. Major Heros Von Borcke, a giant Prussian and favorite member of Stuart's staff, requested permission to help Robertson lead the attack. As Robertson lacked aggressiveness, Stuart no doubt welcomed the request. Von Borcke later described what ensued, and what Rocco recreated on canvas:

"It was already dark by the time we came up with our advanced pickets, about half a mile from Middleburg, and we found them supported by their reserve, under the command of Captain Woolridge of the 4th Virginia, engaged in a lively skirmish with the hostile sharpshooters. We were informed by this brave officer that the Federals held the town in considerable force, and had erected a barricade at its entrance, which he begged as favor to be allowed to storm. This was of course granted; and with a cheer forward went the gallant little band, driving in the tirailleurs rapidly before them, and taking the barricade after a short but sanguinary struggle....As I had felt rather ashamed having been forced to run from the enemy under the very eyes of my fair friends [the ladies of Middleburg], and was naturally anxious to afford them a spectacle of a totally different character, I assumed my place of honour, leading the charge with General Robertson, and to my intense satisfaction plunged into the enemy's ranks opposite the precise spot whence I had commenced my flight, and whence, regardless of danger, the ladies now looked on and watched the progress of the combat. It lasted but a few seconds, for the enemy, unable to withstand the shock of our charge, broke and fled in utter confusion."

Von Borcke can be seen at far right, brandishing his sword and wearing his Stuart-esque style uniform. Robertson appears to the right of the color bearer of the 5th North Carolina Cavalry. [Heros Von Borcke, *Memoirs of the Confederate War.*]

Opposite page:
"Carolinians Forward!"
1992

This page:
"Confederate Cavalry Bugler"
1993

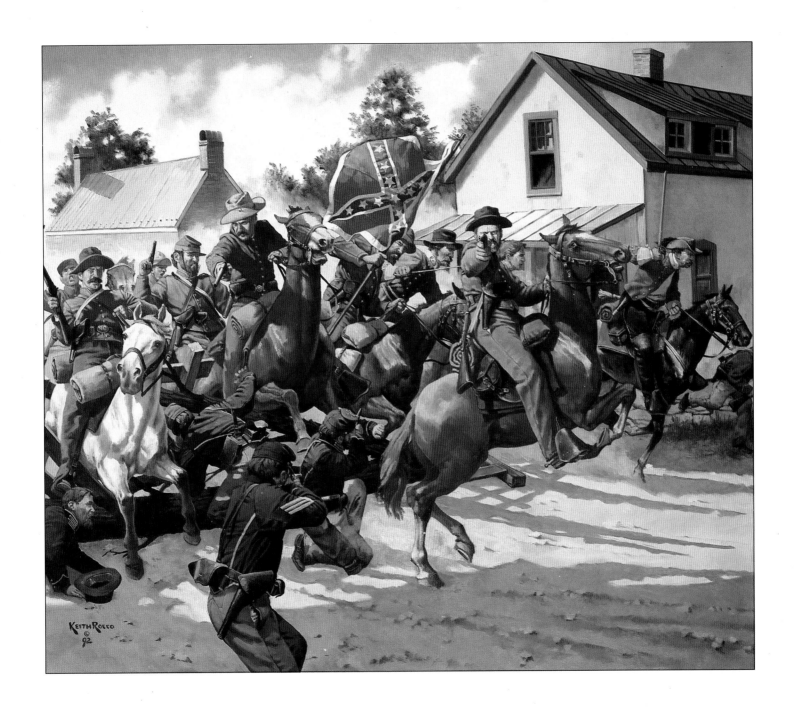

Opposite page:
**"The Chosen Ground:
General John Reynolds and
the Iron Brigade at Gettysburg"**
1993

This page:
"Sergeant, 2nd Wisconsin"
1992

"... forward for God's sake ..."

On the morning of July 1, 1863, Major General John F. Reynolds, commanding the left wing of the Union Army of the Potomac, rode ahead of the 1st Army Corps to Gettysburg to confer with Brigadier General John Buford, whose cavalry division was picketing the Pennsylvania town. Reynolds had instructions from army commander George G. Meade to examine the terrain to see if it was a suitable place to give battle.

A courier told Reynolds that the enemy was advancing along the Chambersburg Pike toward town and that Buford was "sharply engaged." Reynolds spurred ahead, arriving around 10 A.M. After a hasty conference with Buford, Reynolds decided to engage the enemy west of Gettysburg. He told Buford to hold as long as possible, then galloped back to lead his corps forward.

The leading division of the 1st Corps arrived south of town shortly after 10 A.M. Reynolds met it at the Nicholas Codori farm and directed the troops to move toward the Lutheran Theological Seminary. He rode ahead of the infantry to choose their ground. He placed Cutler's brigade and Hall's 2nd Maine Battery on McPherson's Ridge to protect the Chambersburg Road. Reynolds rode toward the woodlot of farmer John Herbst. This, wrote General Abner Doubleday afterward, was the "key of the position" Reynolds had selected. Archer's Tennessee and Alabama brigade had entered the western end of the woods and was driving Buford's dismounted cavalry back, threatening to seize this critical position. Reynolds was counting upon Brigadier General Solomon Meredith's "Iron Brigade" to hold the woods.

It was about 11:00 A.M. when the 2nd Wisconsin, the lead regiment of the Iron Brigade, came double-quicking over Seminary Ridge. As it neared Herbst Woods, Reynolds rode to the front of the regiment, ordered it into line and led it toward Herbst woodlot. Reynolds exhorted the 2nd, "forward men, forward for God's sake and drive those fellows out of those woods." A fierce engagement ensued resulting in the defeat of Archer. But in the first volleys, Reynolds, who had turned in the saddle to look towards the Seminary, was struck in the back of the neck and killed instantly. Reynolds' orderly, Charles Veil, wrote several months later in tribute to his fallen commander: "Wherever the fight raged the fiercest, there the General was sure to be found, his undaunted courage always inspired the men with more energy & courage." [Charles Veil to David McCounaghy, April 7, 1864, Civil War Institute, Gettysburg College.]

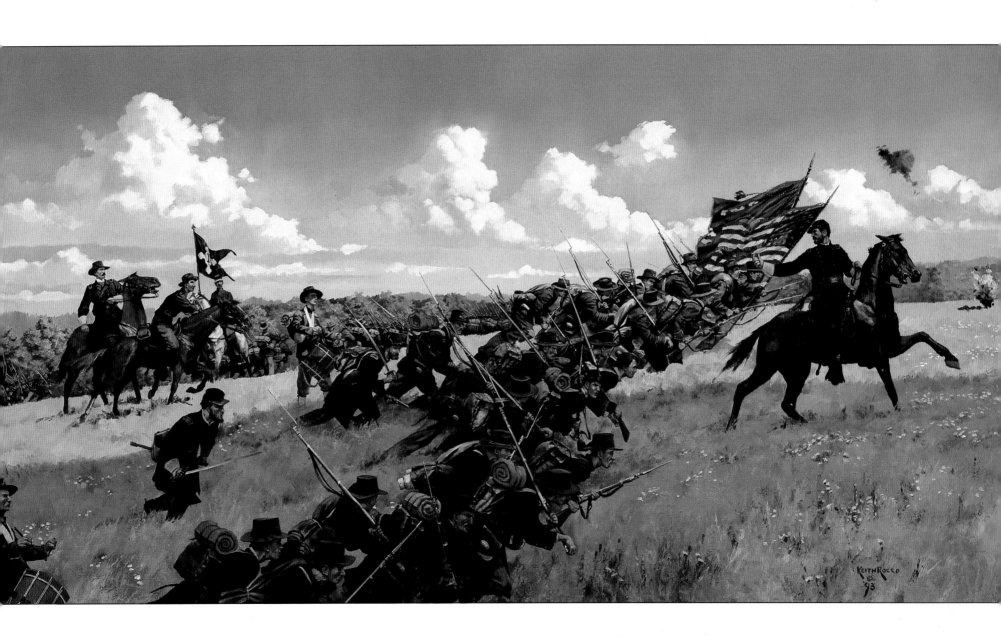

Opposite page:
"The Defense of Little Round Top by the 20th Maine"
1987

This page:
"Joshua Chamberlain"
1993

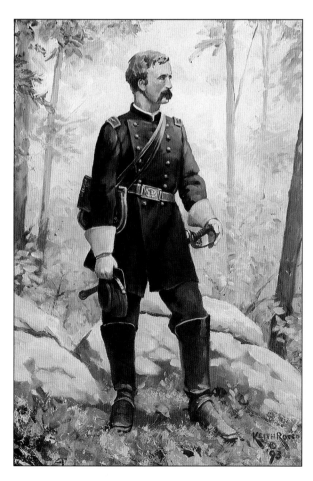

"How men hold on, each one knows – not I."

The stand of Colonel Joshua L. Chamberlain's 20th Maine regiment on Little Round Top at Gettysburg, on July 2, 1863 has become the stuff of legends: a bayonet charge – when all seemed lost – against a numerically superior foe; a bold stroke worthy of veneration.

Keith Rocco depicts the fight for Little Round Top from along the line of the 20th Maine. They had withstood repeated Confederate assaults and were down to their final cartridges. Colonel Chamberlain described the moments before his bayonet charge – a time of tortured uncertainty so poignantly depicted in Rocco's work:

"All around, strange, mingled roar — shouts of defiance, rally, and desperation; and underneath, murmured entreaty and stifled moans; gasping prayers, snatches of Sabbath song, whispers of loved names; everywhere men torn and broken, staggering, creeping, quivering on the earth, and dead faces with strangely fixed eyes staring stark into the sky. Things which cannot be told — nor dreamed. How men hold on, each one knows — not I." [Joshua L. Chamberlain, "Through Blood and Fire at Gettysburg," *Hearst's Magazine.*]

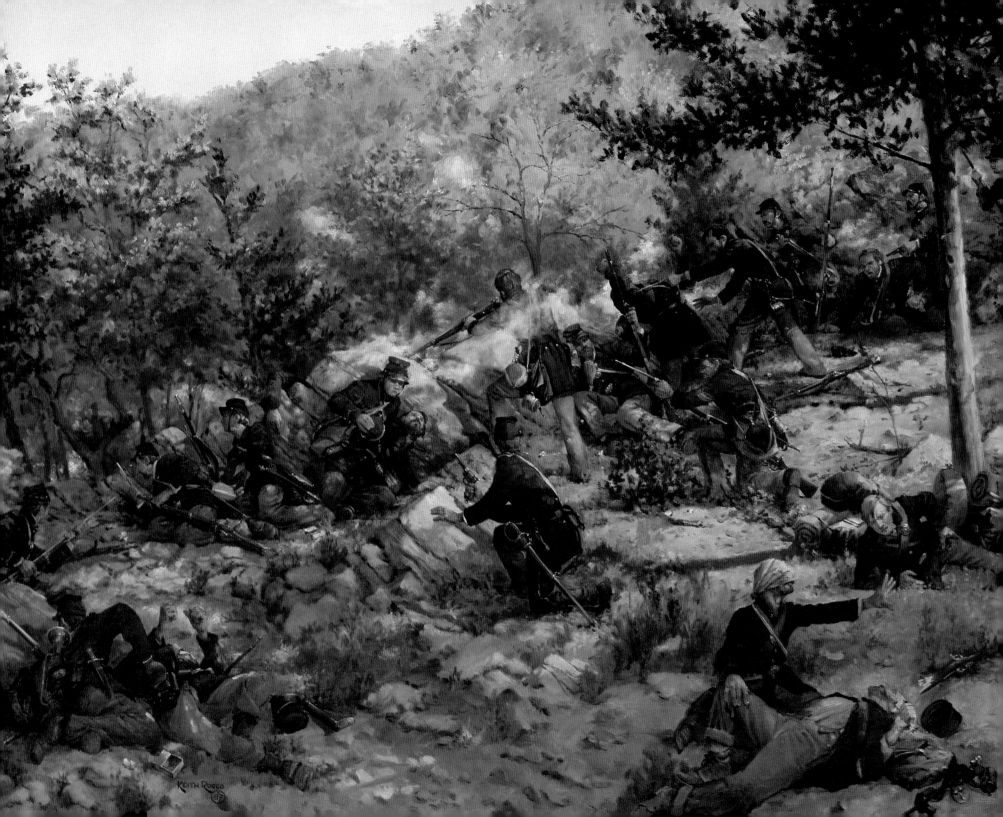

"That day . . . was one of the saddest of my life."

July 3, 1863. Gettysburg, Pennsylvania. General Robert E. Lee gambled on a frontal assault against the Union positions along Cemetery Ridge. He planned to hit the Union line with a crushing bombardment, followed by an infantry attack composed of elements of three divisions, nearly 12,500 men. The burden of coordinating the assault fell to Lee's senior corps commander, Lieutenant General James Longstreet, who held out no hope for its success.

At 1 P.M. nearly 140 Confederate cannon opened up on the Union positions. Federal artillery responded with counter-battery fire. For nearly two hours the artillery duel dragged on, until Confederate ammunition ran low. Late in the cannonade, Colonel Edward P. Alexander, commanding the artillery of Longstreet's 1st Corps, sent a note to Major General George E. Pickett, whose infantry division was waiting to assault the ridge as part of the infantry assault force:

"If you are coming at all, come at once, or I cannot give you proper support, but the enemy's fire has not slackened at all. At least eighteen guns are still firing from the cemetery itself."

Pickett read the note, then handed it to Longstreet. Pickett asked if he should lead his division forward. "That day at Gettysburg was one of the saddest of my life," wrote Longstreet. The burden of command bore heavily. Upon his word, his decision, countless lives could be lost.

"I was convinced that he would be leading his troops to needless slaughter, and did not speak," recalled Longstreet. Pickett repeated the question. "Without opening my lips I bowed in answer," wrote the 1st Corps commander. At this, Pickett mounted his horse and hurried off to set in motion the ill-fated attack that would come to be known as "Pickett's Charge." [Longstreet, "Lee's Right Wing at Gettysburg," *Battles and Leaders*, and *From Manassas to Appomattox*. E. P. Alexander, *Military Memoirs of a Confederate*.]

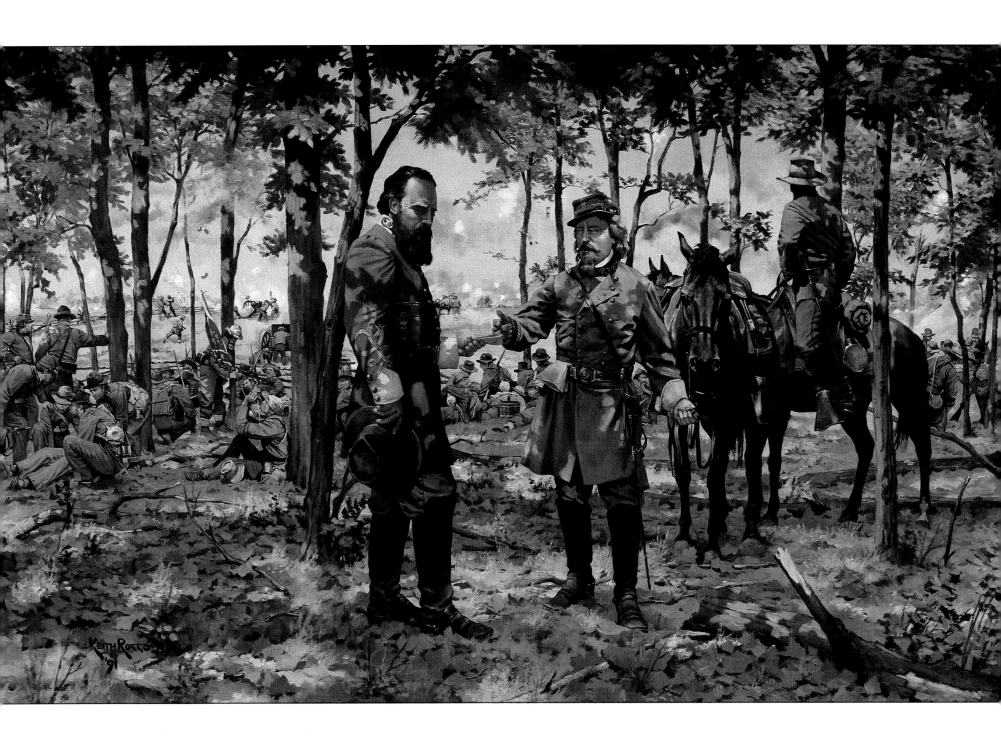

Opposite page:
**"Pickett's Charge:
Hell for Glory"**
1993

This page:
"James Longstreet"
1993

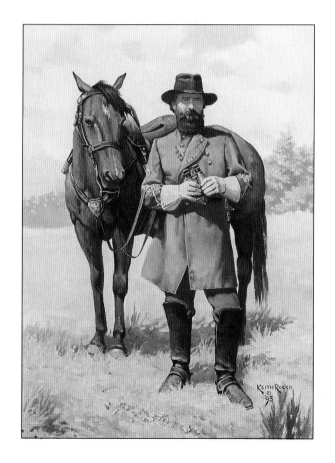

Survivors . . . Pressed On . . .

"There it was again! and again! A sound filling the air above, below, around us, like the blast through the top of a dry cedar or the whirring sound made by the sudden flight of a flock of quail. It was grape and canister." So recalled Captain Henry T. Owen, the thirty-year-old commander of Company C, 18th Virginia Infantry, of the Union artillery fire that tore into his regiment as it stormed the slopes of Cemetery Ridge with Pickett's Division on the fateful 3rd of July, 1863.

Owen's 18th Virginia was part of Brigadier General Richard B. Garnett's brigade, which, along with Brigadier General James L. Kemper's brigade, formed the front line of Pickett's division. Before the assault orders were delivered for all officers to make the advance on foot. Both Kemper and Garnett ignored the order and went forward on horseback. Garnett had little choice if he wished to accompany his men. He had been kicked by a horse and was so lame from his injury that he was unable to walk.

But it was not only his injury that caused Garnett to ride forward with his men. To have remained out of the attack would have been unthinkable. At Kernstown, on March 23, 1862, Garnett had withdrawn his command from a point he believed untenable. It may have been, but his commander, Thomas J. "Stonewall" Jackson, was unforgiving and he relieved Garnett and had him placed under arrest to face a court-martial. To Garnett, Jackson's charges were a humiliating blow to his pride and courage.

Garnett was spared a court-martial and reassigned to a brigade which he led gallantly at Antietam and Fredericksburg. But the stigma was not easily cast off, so Garnett rode forward at Gettysburg to share the dangers with his command.

Hell for Glory captures the moment when Garnett's brigade, having cleared the fences along the Emmitsburg Road, broke into a double-quick. Canister and shrapnel from Cowan's and Cushing's Federal batteries ripped through Garnett's ranks. Moments later Garnett went down, killed by a bullet through the brain. Survivors of his command pressed on until they carried a piece of the stone wall held by Federal troops. Some men joined Brigadier General Lewis B. Armistead when he led a surge over the wall to pierce the Union lines. But that effort, like the assault itself, was unsuccessful. Of the 1,853 officers and men who had followed Garnett in the charge, 182 were killed or mortally wounded, 498 were wounded, and 225 were captured. [Henry T. Owen, "Pickett's Charge," *Gettysburg Compiler.* Anonymous, "About the Death of General Garnett," *Confederate Veteran.* Kathleen Georg, *Nothing But Glory.*]

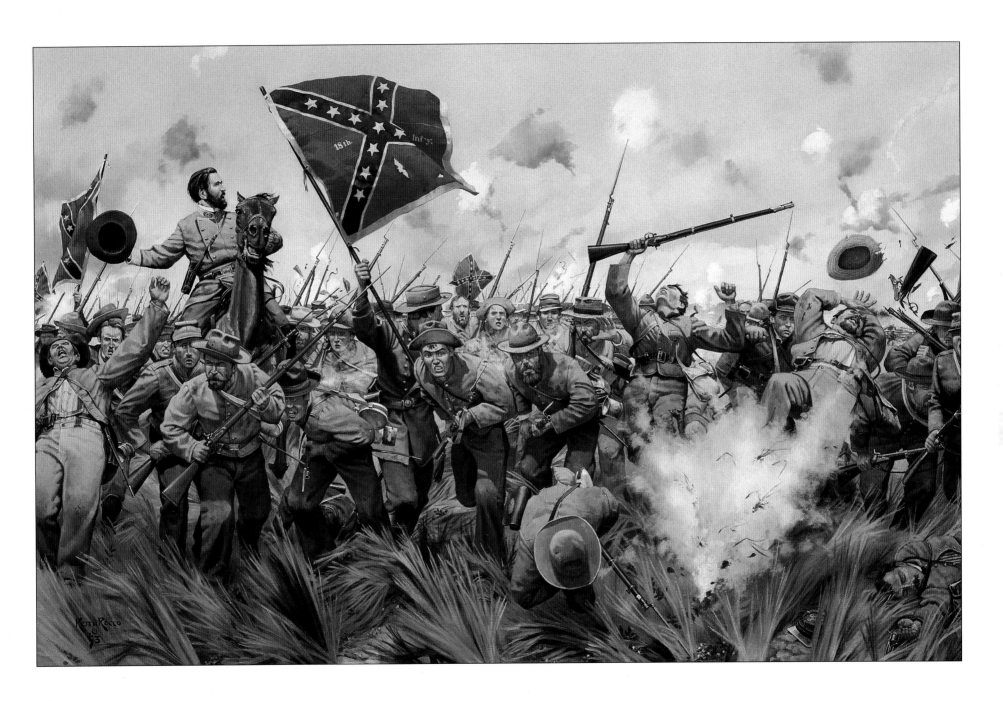

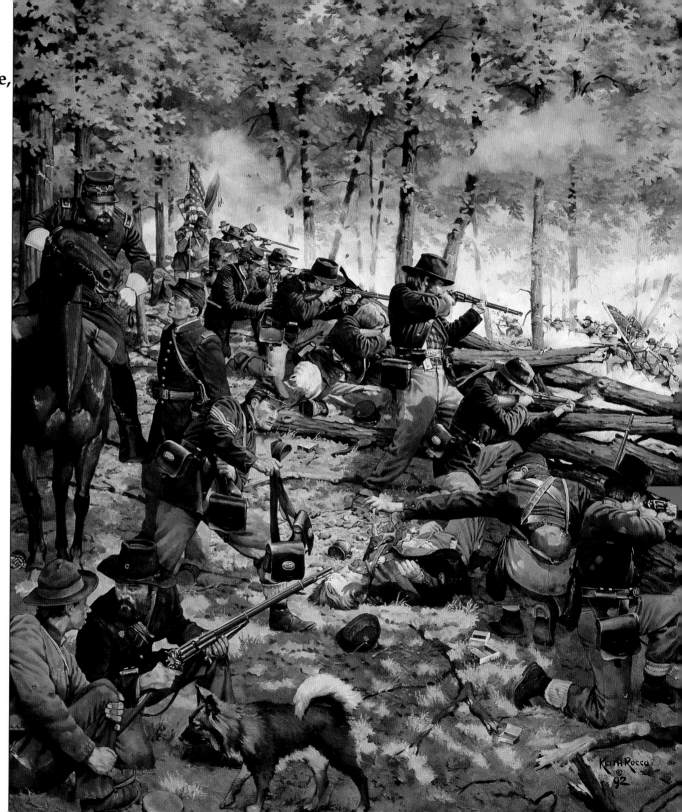

**"To the Last Round:
The 21st Ohio at Horseshoe Ridge,
Chickamauga"**
1992

"I thought you had a whole division . . ."

September 20, 1863. The Union center at Chickamauga gave way under an assault by Confederate General James Longstreet's left wing of Braxton Bragg's Army of Tennessee. Major General William S. Rosecrans' Army of the Cumberland faced not only defeat, but a potential rout. Nearly one-half of the Federal army fled the field. But an element of Major General John Brannan's division of Major General George H. Thomas's corps took position on a series of heavily forested hills, ridges, and ravines known as Horseshoe Ridge. It covered the McFarland Gap Road, the only line of retreat left open to Thomas's men. The position had to be held.

The right of Brannan's line that formed to meet the flood tide of advancing Confederates was held by the 21st Ohio, a large regiment of 554 officers and men, many of whom were armed with Colt Revolving Rifles. The first two Confederate attacks that struck the ridge were uncoordinated and easily driven back by Brannan's Federals. The Confederates reorga-nized and reinforced their front. At 2 P.M. they struck again. On the extreme right of Brannan's line, the 21st Ohio was in the critical position. If it gave way, Brannan's entire line would be outflanked and forced to withdraw.

Following an ineffectual artillery bombard-ment, the Confederate infantry of Patton Anderson swept up the slope of Horseshoe Ridge. They encountered a terrific fire from the 21st's Colt Revolving Rifles, and although some men of Anderson's brigade advanced to within thirty feet of the 21st's line, they could go no farther. The Southerners gave way and retreated down the hill. One young Mississippian dropped his musket and dashed into the 21st's line to surrender himself. When he observed the thin line of the 21st, he was heard to exclaim: "My God! I thought you had a whole division here."

Anderson's first assault had scarcely been repulsed when he sent forward his second line to assail Horseshoe Ridge. Again, the murder-ous fire laid down by the Colt Rifles brought the advance to a halt, but the Confederates this time stubbornly held their ground and returned the fire. This is the moment captured in the painting.

The 21st is nearly out of ammunition, hav-ing fired off most of the 95 rounds per man they had carried into the battle. Just in rear of the 21st's firing line, Major Arnold McMahan, commanding the regiment in place of its wounded colonel, orders seventeen-year-old 2nd Lt. Wilson Vance to have his men fire off their last rounds and retire up the hill. In front of Vance, Ordnance Sergeant John Bolton pass-es out cartridge boxes he had gathered from the bodies of the dead and wounded.

For six long hours the 21st fought upon the slopes of Horseshoe Ridge. Their stand has been deemed the "the most distinguished ser-vice rendered by any single regiment at Chickamauga." Out of ammunition, the regi-ment was captured late in the day. Their stub-born resistance purchased time for reinforce-ments to stabilize the Union hold on Horseshoe Ridge, and help General George Thomas avert a disaster, earning him the sobri-quet: "Rock of Chickamauga." [Peter Cozzens, *This Terrible Sound: The Battle of Chickamauga.*]

"Give me the flag."

"The sky was clear, and the air was fresh and bracing," said the historian of the 93rd Illinois Infantry of the morning of November 25, 1863. The Union Army of the Tennessee and Army of the Cumberland were poised to storm the slopes of Missionary Ridge, near Chattanooga, Tennessee. It was two months since the Union defeat at Chickamauga. Now, under the leadership of Ulysses S. Grant, the Federal forces were poised to avenge that disaster.

The 93rd Illinois was part of Major General William T. Sherman's Army of the Tennessee. It had drawn the unenviable assignment of storming Tunnel Hill, the northern-most eminence of Missionary Ridge, through which the Chattanooga and Cleveland Railroad passed. This track was the lifeline of Braxton Bragg's Army of Tennessee.

Bragg had foreseen the impending blow and strengthened the position at Tunnel Hill with perhaps the best division in his army, that of Pat Cleburne. Cleburne's position was well suited to defense. To reach the foot of the hill the Federal infantry had to first cross broad open fields.

Sherman's initial assaults were unsuccessful, and at 1:30 P.M., Charles Matthies' brigade advanced to the attack. Its objective was a farm at the base of the hill, but events modified orders, and the 93rd Illinois led the brigade up the slope. Under a heavy fire the Illinoisans advanced nearly to the summit, "within twenty paces of the enemy's lines." Here, recalled the regimental historian, they fought nearly two and one half hours. "It was a most desperate struggle, if not a useless one."

In the first twenty minutes of fighting near the summit, the colors of the 93rd were "shredded in twenty places." The bearer of the national colors fell. Sergeant Erwin picked them up and held them aloft, but he was instantly shot down. Then occurred the incident captured by **Never Forsake the Colors**. The adjutant of the 93rd took the colors from the grasp of the mortally wounded Sergeant Erwin. Colonel Holden Putnam, the commander of the 93rd, on horseback, realized that he needed to get his stalled advance going.

Putnam rode up to his adjutant and commanded, "Give me the flag." One soldier who witnessed the scene recorded in his diary: "The Col. took the colors on his horse and waved them telling the boys never to forsake them and at that moment he was shot dead...the ball penetrating his brain." Lt. Colonel Nicholas C. Buswell, who assumed command in Putnam's stead, reported afterward: "His (Putnam's) loss we feel keenly. The regiment has lost a brave and gallant commander, and the country a willing, earnest and able defender."

The 93rd Illinois fought on, but with the remainder of the brigade was eventually thrown off the hill.

The scene shown here was enacted upon many battlefields; an officer seizing the flag of his regiment to inspire the men to rally or go forward. All too often they shared Putnam's fate. [Harvey Trimble, *History of the Ninety-Third Regiment Illinois Volunteer Infantry*. Peter Cozzens, *The Shipwreck of Their Hopes: The Battles for Chattanooga*.]

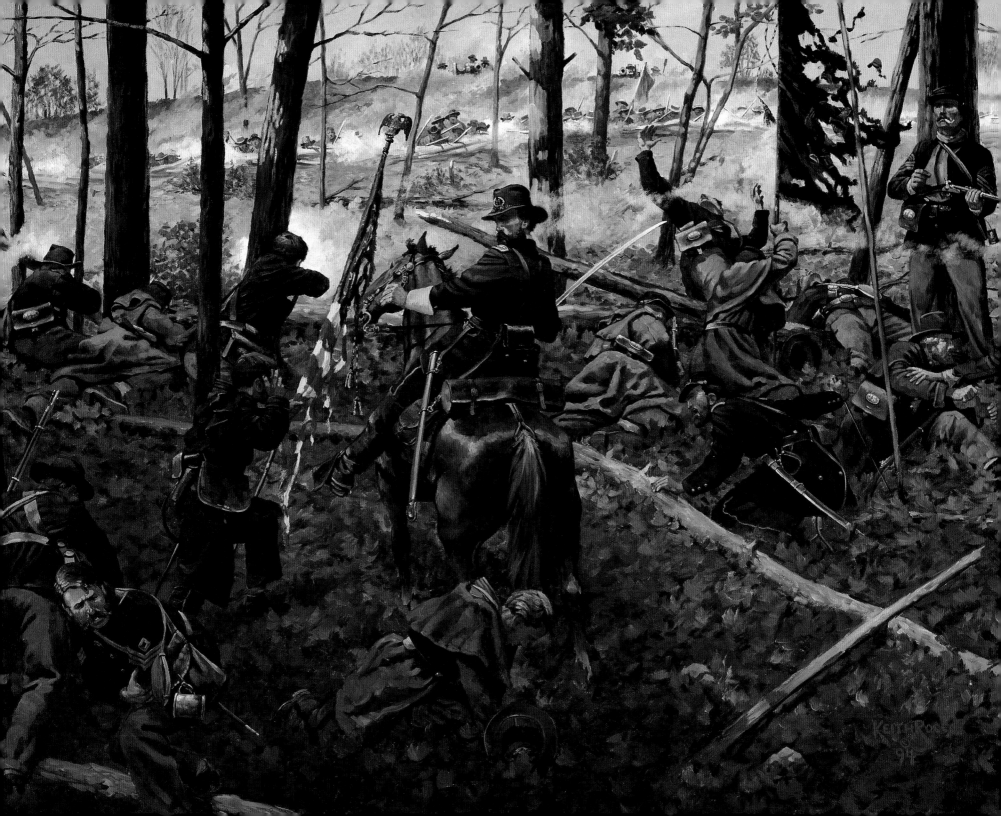

"Into the Wilderness: The 140th and 146th New York at Sanders' Field"
1990

"Away we charged over the field . . ."

On May 4, 1864 the Army of the Potomac entered the dense, wooded region in northern Virginia known simply as the Wilderness. Ulysses S. Grant had pushed the Union army forward in search of a showdown battle, but he hoped to be clear of the Wilderness before Lee could engage him. The orders for Major General Gouverneur K. Warren's 5th Corps, to which the 140th and 146th New York regiments belonged, were to advance west toward Orange Court House, using the Orange Turnpike to guide their movements.

Before Warren could step off, word came back from the picket line that thousands of enemy soldiers were deploying in the woods on either side of the turnpike. It was Lieutenant General Richard Ewell's 2nd Corps. Lee had arrived and Grant would not pass through the Wilderness without a battle.

The 140th and 146th were part of Brigadier General Romeyen B. Ayres' brigade. The heavy casualties of 1862 and 1863 had led to the consolidation of many units. Ayres had been reinforced by the old brigade of Brigadier General Stephen Weed, who had been killed at Gettysburg, consisting of the 140th and 146th New York, and 91st and 155th Pennsylvania. In the fall of 1863 these four regiments had been entirely outfitted in Zouave uniforms, which pleased the men greatly, for it set them apart as a unit with an elite appearance.

The brigade struggled through a mile of dense forest to reach an oval shaped clearing called Sanders' Field, approximately 500 yards wide and 400 yards long. The turnpike ran through the field. Ayres' first line entered Sanders' Field in good order. Immediately they came under fire from Confederates of George H. Steuart's brigade. Two other Confederate brigades cut the Federal line with an enfilading fire. The Federals reached the western edge of the field where they rushed forward to engage Steuart's Confederates at close range.

As the front line became entangled with the enemy, the second line waited its turn. The regimental historian of the 146th New York recalled the next few minutes:

"A shrill blast of the bugle gave the order for us to advance to the support of the One Hundred and Fortieth....and the regiment marched forward in line of battle, officers in front and the men in close ranks....Away we charged over the field, preserving our alignment as well as we could....

"Just as we reached the gully, a withering volley of musketry was poured into our line, followed by a moment later by another....Paying but slight heed to our stricken comrades, the rest kept on, with clenched teeth, breathing in quick gasps from the exertion of running and the excitement of battle."

This is the moment depicted in Rocco's **Into the Wilderness**. The 140th is already grappling with Steuart's Confederates, while the 146th rushes through a cutting fire to succor their comrades. The battle soon became hand-to-hand in places.

The statistics of the battle in Sanders' Field for the 140th and 146th were grim. In the 140th, 265 officers and men were casualties out of 529 engaged. The 146th added 316 killed, wounded, and captured out of 580 officers and men. All of this had been suffered in a span of time that "may not have been more than five or ten minutes." [Brainard, Mary G. G., ed., *Campaigns of the One Hundred and Forty-Sixth Regiment New York State Volunteers.*]

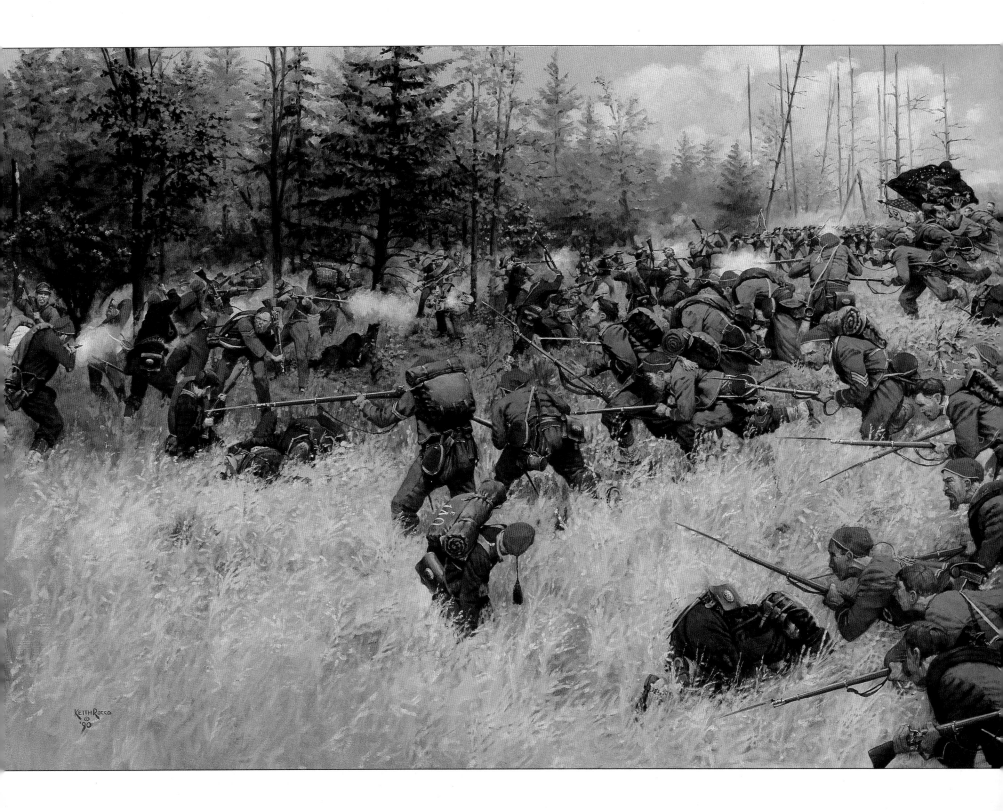

**"On the Rim of the Volcano:
Battle of Franklin, Tennessee"**
1992

". . . walking over the wounded and dead . . ."

For the Confederate soldier of the Army of Tennessee, few battles of the war were as horrible or senseless as Franklin. In a foolhardy bid for victory, John B. Hood hurled his army of 23,000 men at the formidable Union fortifications surrounding Franklin, Tennessee on November 30, 1864. This painting depicts a stalled drive against a salient in the Union line near the Fountain B. Carter family cotton gin. S. A. Cunningham of the 41st Tennessee recalled the terror that Rocco has captured on canvas:

"The works were so high that those who fired the guns were obliged to get a footing in the embankment, exposing themselves in addition to their flank, to a fire by men in houses. One especially severe was that from Mr. Carter's, immediately in my front...When the men so exposed were shot down, their places were supplied by volunteers until these were exhausted, and it was necessary for General Strahl to call upon others. He turned to me, and though I was several feet back from the ditch, I rose up immediately, and walking over the wounded and dead, took position with one foot upon the pile of bodies of my dead fellows, and the other in the embankment, and fired guns which the General himself handed to me until he, too, was shot down. [S. A. Cunningham, "The Carnage at Franklin, Tennessee," *Southern Historical Society Papers*.]

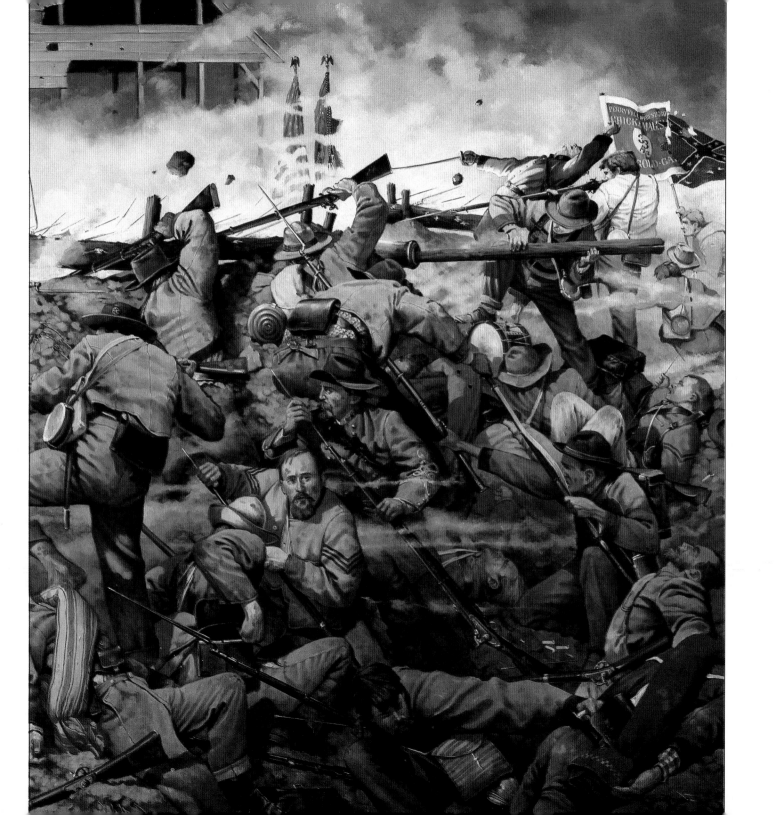

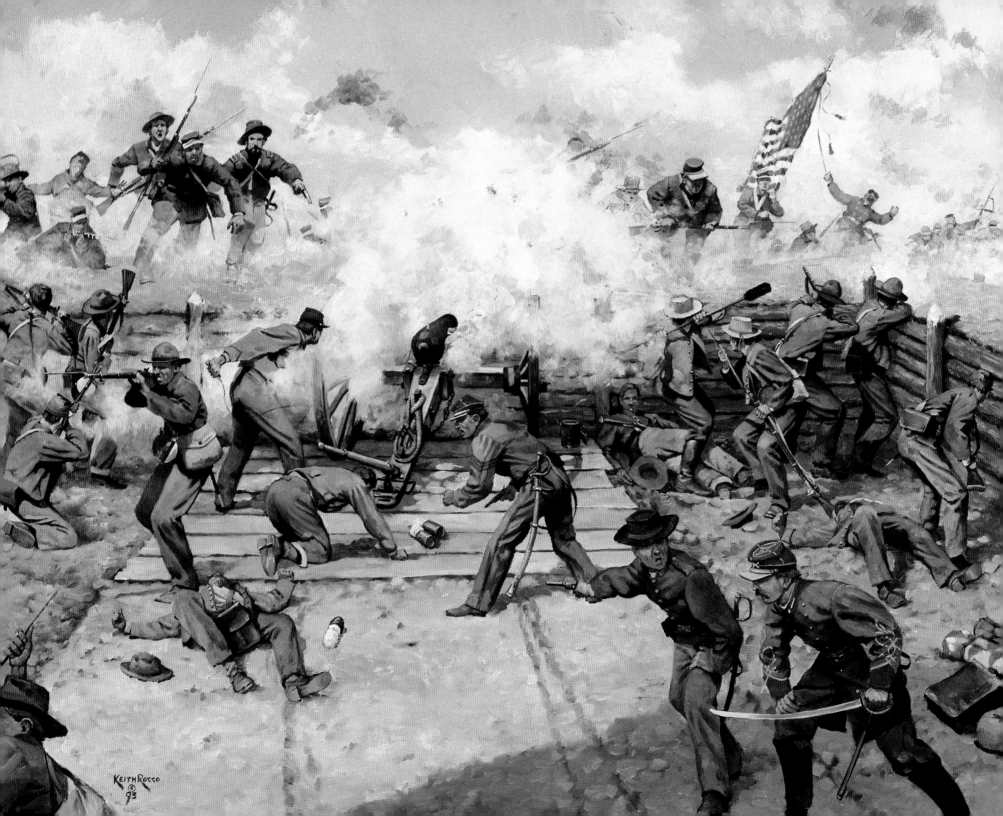

"We were prepared for the worst . . ."

It was the last days of the Confederacy. The Petersburg defenses, which had held for ten months, were crumbling. To help cover the retreat of the Army of Northern Virginia from the Petersburg lines, it was necessary to hold Fort Gregg and nearby Fort Baldwin to the last moment. This duty fell to the brigade of Brigadier General Nathaniel H. Harris, which was composed of the 12th, 16th, 19th, and 48th Mississippi Infantry.

On April 2, 1865, Harris placed the 12th and 16th in Fort Gregg, and the 19th and 48th in Fort Baldwin. Gregg was soon assailed by elements of two divisions, a total of five infantry brigades, from Major General John Gibbon's 24th Corps. The engagement was vividly recalled by Captain A. K. Jones, commanding the 12th Mississippi:

"When the cannonading ceased, the infantry advanced...until they got in range of our rifles, when we pelted them right merrily, and so effectively that they retired out of range; but soon their lines were reformed, and then they came in a run. Their battle lines were three-fourths of a mile long, but before getting to the fort they were solid masses of men.

"In these charges there was no shooting but by us....When they got in twenty-five or thirty yards of the fort they were safe, for we could not see them again until they appeared upon the parapet.

"When General Gibbon saw that the fort was not captured, he started his second column of a thousand or fifteen hundred men, and we gave them the same warm welcome that we gave the first, and more of it.

"As soon as this column reached shelter and recovered breath they attempted to climb over the parapet, but no sooner was a head seen than it was withdrawn with a minnie ball in it. When it was realized that nothing more could be expected from the men in the trenches around the fort, then the third and stronger column started, and we had harder work to keep them out....There were six of these assaulting columns, and they followed each other about every thirty minutes, and each successive one was harder to drive off the parapet, and when the fort was finally captured, the parapet was covered with dead men in blue.

"I am satisfied that the last assaulting column walked on the heads of the other columns, who were packed in the ditch like sardines in a box, for they made no halt at all, but rushed right on over the parapet into the fort.

"Before the last assault was made the battle flags of the enemy made almost a solid line of bunting around the fort....We were prepared for the worst, and expected no quarter.

"Many of our captors were under the influence of whisky, and all were exasperated that we should have made such a stubborn fight, entailing on them a bloody massacre, when resistance was useless and vain.

"So the cry was to kill, and but for their officers, who with cocked pistols made the men desist, all of us would have been murdered, and then too the jam of men in the fort gave us some protection, for it was impossible almost to shoot a Confederate without hitting a Federal. We lost about forty men killed in the fort after its capture, and fully that many Federals were killed by their own men.

"It was ten minutes before the sh[] could be suppressed." [A. K. Jones, "Th[] of Fort Gregg," *Southern Hist. Society* []

The Aftermath

Text by D. Scott Hartwig and Peter Cozzens

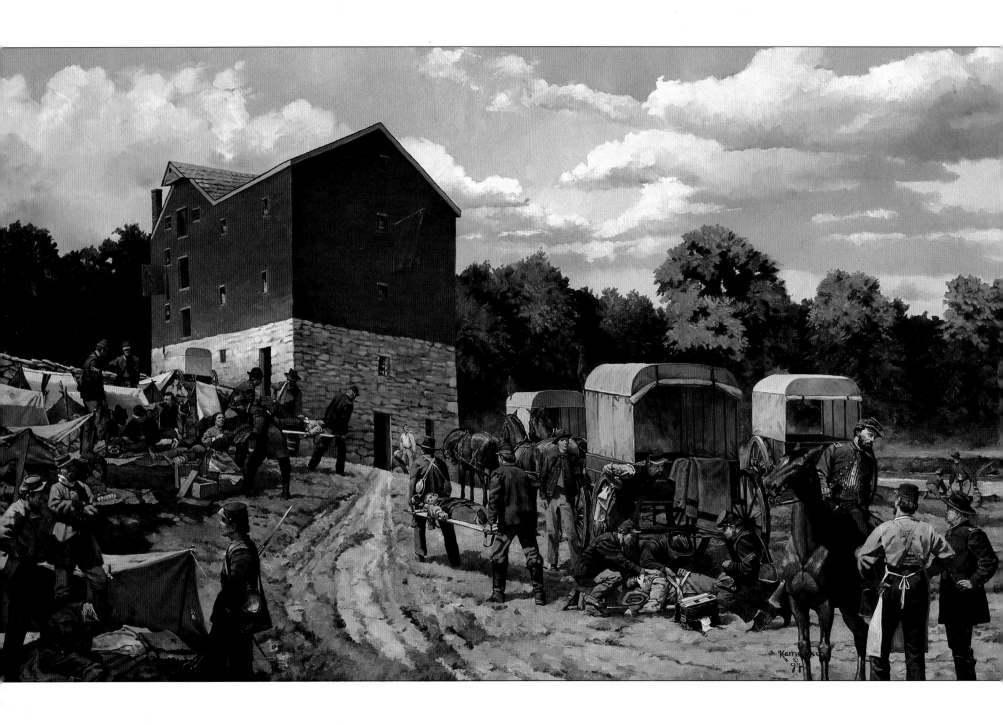

"Besides fingers and toes I have made eleven amputations . . ."

The single day battle of Antietam left 18,273 wounded in its wake, taxing the medical services of both armies to their limits. The Union Army of the Potomac was fortunate to have Surgeon Jonathan Letterman as its medical director. Letterman, pictured on horseback in front of the ambulances delivering wounded, was a brilliant organizer who had developed a highly efficient system of removing wounded from the battlefield and treating them.

When it was evident there would be a battle at Antietam, Letterman wrote: "Directions were given to the medical directors of corps to form their hospitals...at such a distance in the rear of the line of battle as to be secure from the shot and shell of the enemy; to select the houses and barns most easy of access...to designate barns as preferable in all cases to houses, as being at that season of the year well provided with straw, better ventilated, and enabling the medical officers with more facility to attend to a greater number of wounded, and to have all the hospital supplies taken to such points...."

One such divisional hospital was established at the Samuel Pry mill, on the banks of Antietam Creek. A lack of adequate supplies plagued the medical efforts of both armies. For the Federal wounded, civilian groups and individuals came quickly to the battlefield to offer their help. One such was Clara Barton, a former Washington Patent Office Clerk and future founder of the American Red Cross, who served as a civilian nurse. She is depicted distributing blankets to the wounded.

Although Letterman's medical services performed remarkably well, conditions in the hospitals of Antietam were horrific. Wrote Theodore Dimon, surgeon of the 2nd Maryland Infantry, to his wife eight days after the battle:

"I am slowly traveling through the disposal of and provision for 140 poor fellows under my care here. Surgery, surgery, surgery. Food, food, food. Nurses, nurses, nurses. Cooks that get drunk. Everybody employed looking out for No. 1; nobody caring for anybody else.

"I came here and in two log houses and a barn the Medical Director had deposited 140 wounded on the bare floors. They had not even straw under them. There was not a cook, nurses or anything for them, and no provisions, dressings or anything else....Well I seized upon stragglers, orchard thieves and anything, and made a guard of six men; gave them muskets. I then detailed out of the rest 5 cooks, 12 nurses and got my own steward. I got a broken ambulance and sent it off after dressings, medicines, food and candles. Then went to work at the wounds....And arresting nurses, cooks and general thieves and substituting others in their places; answering 40,000 questions from everybody meanwhile.

"Besides fingers and toes I have made eleven amputations here of legs, thighs, forearms, arms and at shoulder joint....Last night at eleven o'clock after three hours of writing names, regiment, company, rank, wounds, when received, how treated, etc., etc., I went to bed and for the first time in a month I dreamed of home and you. I hope the dream will come true." [*The War of the Rebellion: The Official Records of the Union and Confederate Armies.* James Robertson Jr., ed., "A Federal Surgeon at Sharpsburg," *Civil War History.*]

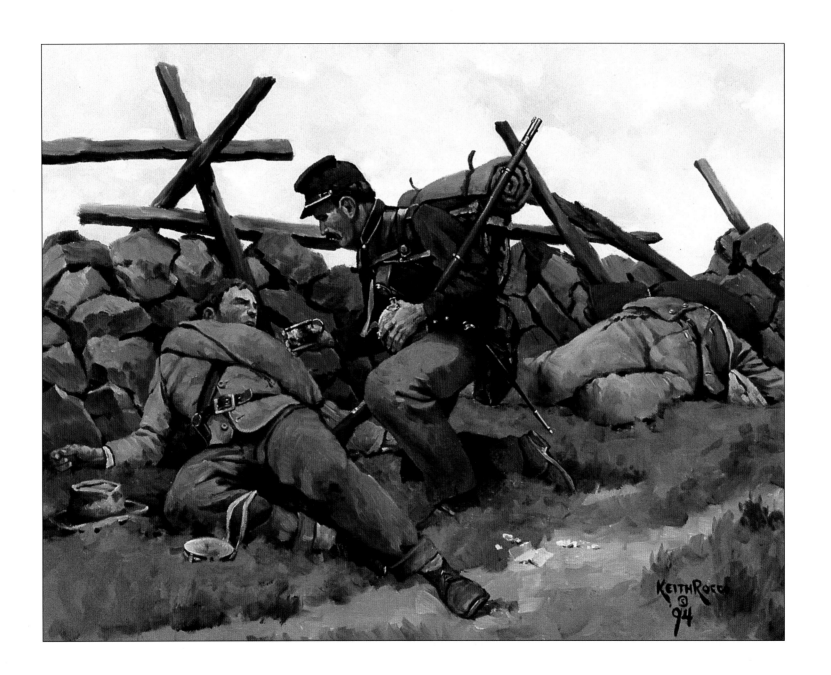

Opposite page:
"Friend or Foe"
1994

This page:
"Where the Colors Stood"
1994

"... covered with dead heroes ..."

No position in American Civil War combat was as dangerous as that of the regimental color guard. The purpose of the colors was functional: they served as a visual means of communication, to guide the regiment's movements, to rally the men when their formation was broken, and to inspire the men to go forward.

Few men survived to carry the colors through the war. The color guard always drew the heaviest fire in battle. The moving and pathetic scene of **Where the Colors Stood** was enacted upon many battlefields of the war. Sergeant George Kimball, of the 12th Massachusetts Infantry, described such a moment at Antietam, where his regiment lost 213 men out of 325 engaged:

"The colors of the 12th were toward the close of the fight flying from their poles while the latter were stuck in the ground. As the regiment started for the rear Lieut. Arthur Dehon picked them up from where they had fallen. They were literally covered with dead heroes — those who had been killed beneath them or had been wounded and crawled upon them to die. It was only with difficulty that Dehon could get possession of these sacred emblems of patriotism and valor." [J. H. Stine, *Army of the Potomac*.]

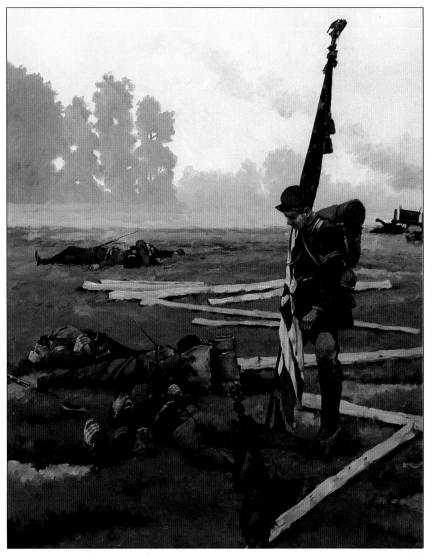

Appendix

The following list is a chronology of Keith Rocco's finished works.

1985

"Cavalry Reconnaissance"
Private collection.

"Confederate Cavalry Bugler"
Private collection.

1986

"The Stonewall: Jackson at Manassas"
Private collection.

"First Sergeant"
Private collection.

Illustrations for *Civil War Times Illustrated.*
Artist's collection.

"Pickets in Fredericksburg"
Private collection.

"A Short Rest"
Private collection.

"Union Infantry Lieutenant"
Private collection.

"LaFourche Creoles, Co. G, 18th La."
Private collection.

1987

"Drummer, 5th Corps"
Private collection.

"Through the Cornfield"
Corporate collection.

"Counterattack: The West Woods"
Private collection.

"Eye to Eye Along the Hagerstown Turnpike"
Private collection.

"The Defense of Little Round Top by the 20th Maine"
Artist's collection.

1988

"Port Republic"
Artist's collection.

"Retreat"
Private collection.

"Lee at Appomattox"
Private collection.

1989

"Thomas, The Rock of Chickamauga"
Private collection.

1990

"Skirmishing"
Private collection.

"The Outpost: North"
Private collection.

"The Outpost: South"
Private collection.

"Into the Wilderness: The 140th and 146th New York at Sanders' Field"
Private collection.

"Confederate Reconnaissance"
Private collection.

1991

"5th New York at Gaines Mill"
Private collection.

"The Burden of Command: Longstreet and Pickett at Gettysburg"
Army War College collection.

"The Color Guard: 6th and 15th Texas Consolidated"
Artist's collection.

"Berdan's Sharpshooters at Gettysburg"
Private collection.

1992

"On the Rim of the Volcano: Battle of Franklin, Tennessee"
Private collection.

"Sergeant, 2nd Wisconsin"
Private collection.

"Carolinians Forward!"
Artist's collection.

Mural of the Antietam Cornfield for the Wisconsin Veterans Museum.

"To the Last Round: The 21st Ohio at Horseshoe Ridge, Chickamauga"
Private collection.

1993

"Pickett's Charge: Hell for Glory"
Artist's collection.

"The Chosen Ground: Gen. John Reynolds and the Iron Brigade at Gettysburg"
Artist's collection.

"The Bivouac: Meade at Gettysburg"
Artist's collection.

"The Veteran"
Private collection.

"Sunday Morning in Camp"
Artist's collection.

"Confederate Officers in the Valley"
Private collection.

"Fort Gregg, Petersburg"
National Guard collection.

"Federal Infantry Bugler"
Private collection.

"Confederate Infantry Bugler"
Private collection.

"Confederate Cavalry Bugler"
Private collection.

"James Longstreet"
Private collection

"Joshua Chamberlain"
Private collection.

"John Buford"
Private collection.

"Nathan Bedford Forrest"
Private collection

1994

"In Reserve: The Bombardment of Lookout Mountain"
Artist's collection.

"Friend or Foe"
Private collection.

"Fix Bayonets! Joshua Chamberlain and the 20th Maine at Little Round Top"
Artist's collection.

"Confederate Color Bearer"
Private collection.

"Confederate Study"
Private collection.

"Scouting the Ford"
Artist's collection.

"Cleburne at Ringgold Gap"
Artist's collection.

"Where the Colors Stood"
Artist's collection.

"Island of Mercy: The Pry Mill at Antietam"
Private collection.

"The Fifes and Drums"
Artist's collection.

"Never Forsake the Colors! The 93rd Illinois at Tunnel Hill"
Private collection.

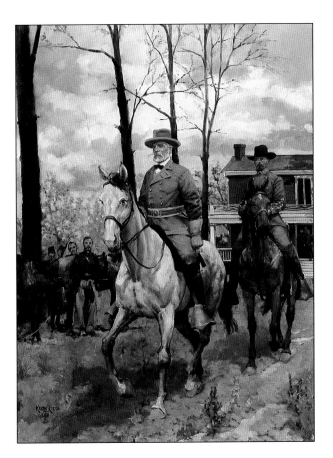

"Lee at Appomattox"
1988